D. Brady

ESCAPE FROM CAPTIVITY!

'Behold, the days come,
that all that is in thine house,
and that which thy fathers
have laid up in store . . .
shall be carried to Babylon.'
ISAIAH 39: 6

The Bible Retold in Pictures

In the Beginning
The Promised Land
Kings and Prophets
Escape from Captivity!
The Life Of Jesus
The First Christians

The Bible Retold in Pictures

ESCAPE FROM CAPTIVITY!

DRAGON
GRANADA PUBLISHING
London Toronto Sydney New York

Published by Granada Publishing Limited
in Dragon Books 1980

ISBN 0 583 30391 9

First published in USA by David C. Cook
Publishing Company 1978
Copyright © David C. Cook Publishing Company 1978
All rights reserved

Granada Publishing Limited
Frogmore, St Albans, Herts AL2 2NF
and
3 Upper James Street, London W1R 4BP
866 United Nations Plaza, New York, NY 10017, USA
117 York Street, Sydney, NSW 2000, Australia
100 Skyway Avenue, Rexdale, Ontario, M9W 3A6 Canada
PO Box 84165, Greenside, 2034 Johannesburg, South Africa
CML Centre, Queen and Wyndham, Auckland 1, New Zealand

Printed and bound in Great Britain by
William Clowes (Beccles) Limited
Beccles and London

Granada ®
Granada Publishing ®

Contents

Chariot of Fire!

FROM II Kings 2: 11-18; 4: 1

ELISHA ASKS FOR THE SPIRITUAL POWER TO CARRY ON ELIJAH'S WORK. AND ELIJAH PROMISES: "IF YOU SEE ME WHEN I AM TAKEN FROM YOU, IT WILL BE A SIGN THAT GOD HAS GRANTED YOUR WISH." SUDDENLY A CHARIOT OF FIRE SWEEPS DOWN AND SEPARATES ELIJAH FROM ELISHA, AND ELIJAH IS TAKEN UP IN A WHIRLWIND...

ELIJAH! ELIJAH! I SEE NOW--THE POWER THAT PROTECTED AND GUIDED YOU IS GREATER THAN ALL THE ARMIES OF EARTH!

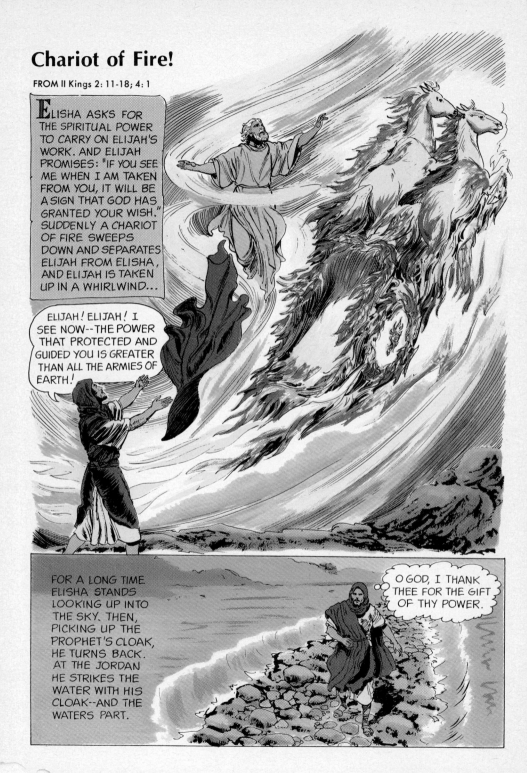

FOR A LONG TIME ELISHA STANDS LOOKING UP INTO THE SKY. THEN, PICKING UP THE PROPHET'S CLOAK, HE TURNS BACK. AT THE JORDAN HE STRIKES THE WATER WITH HIS CLOAK--AND THE WATERS PART.

O GOD, I THANK THEE FOR THE GIFT OF THY POWER.

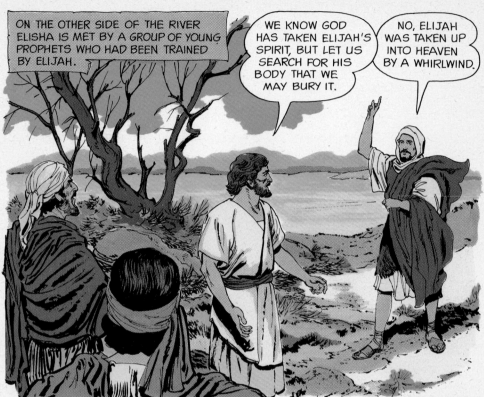

ON THE OTHER SIDE OF THE RIVER ELISHA IS MET BY A GROUP OF YOUNG PROPHETS WHO HAD BEEN TRAINED BY ELIJAH.

WE KNOW GOD HAS TAKEN ELIJAH'S SPIRIT, BUT LET US SEARCH FOR HIS BODY THAT WE MAY BURY IT.

NO, ELIJAH WAS TAKEN UP INTO HEAVEN BY A WHIRLWIND.

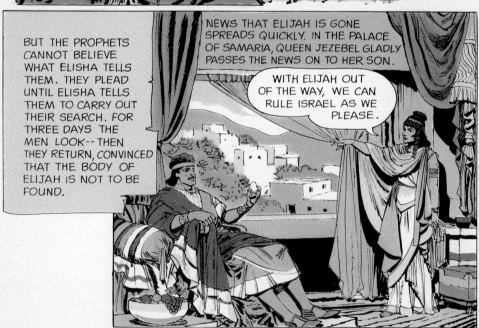

BUT THE PROPHETS CANNOT BELIEVE WHAT ELISHA TELLS THEM. THEY PLEAD UNTIL ELISHA TELLS THEM TO CARRY OUT THEIR SEARCH. FOR THREE DAYS THE MEN LOOK-- THEN THEY RETURN, CONVINCED THAT THE BODY OF ELIJAH IS NOT TO BE FOUND.

NEWS THAT ELIJAH IS GONE SPREADS QUICKLY. IN THE PALACE OF SAMARIA, QUEEN JEZEBEL GLADLY PASSES THE NEWS ON TO HER SON.

WITH ELIJAH OUT OF THE WAY, WE CAN RULE ISRAEL AS WE PLEASE.

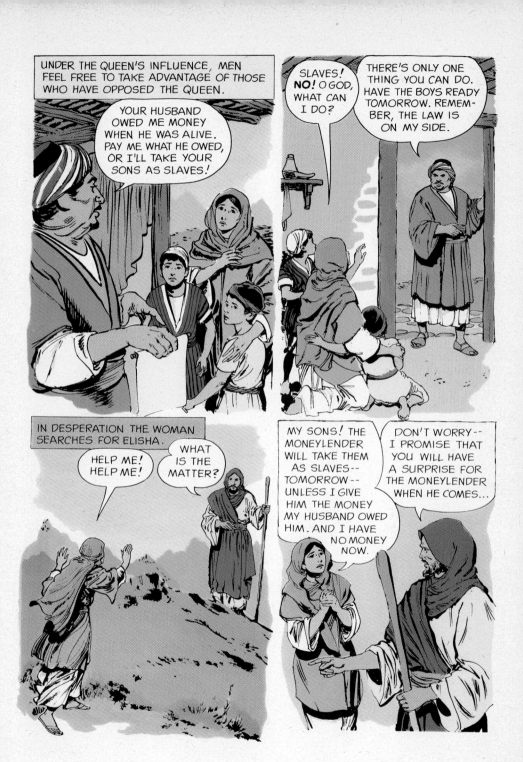

A Miracle of Oil

FROM II Kings 4: 2-7

ELISHA PROMISES A SURPRISE FOR THE MONEYLENDER WHO DEMANDS THAT A WIDOW GIVE HER SONS IN PAYMENT FOR A DEBT SHE CANNOT PAY.

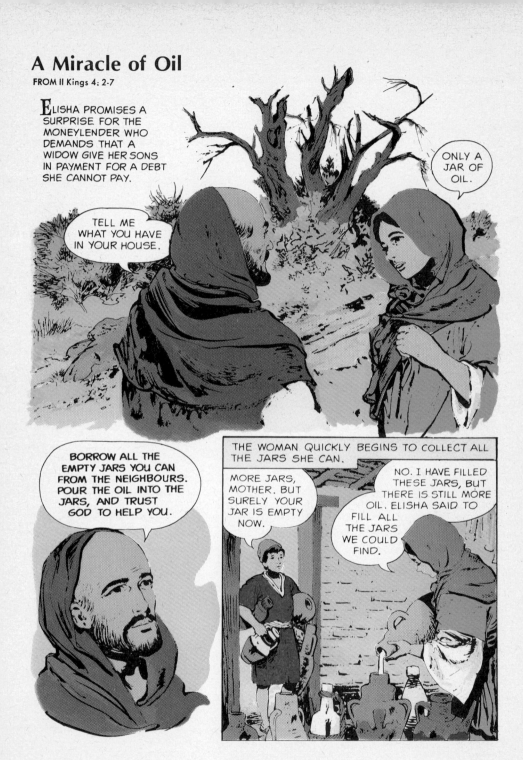

ONLY A JAR OF OIL.

TELL ME WHAT YOU HAVE IN YOUR HOUSE.

BORROW ALL THE EMPTY JARS YOU CAN FROM THE NEIGHBOURS. POUR THE OIL INTO THE JARS, AND TRUST GOD TO HELP YOU.

THE WOMAN QUICKLY BEGINS TO COLLECT ALL THE JARS SHE CAN.

MORE JARS, MOTHER. BUT SURELY YOUR JAR IS EMPTY NOW.

NO. I HAVE FILLED THESE JARS, BUT THERE IS STILL MORE OIL. ELISHA SAID TO FILL ALL THE JARS WE COULD FIND.

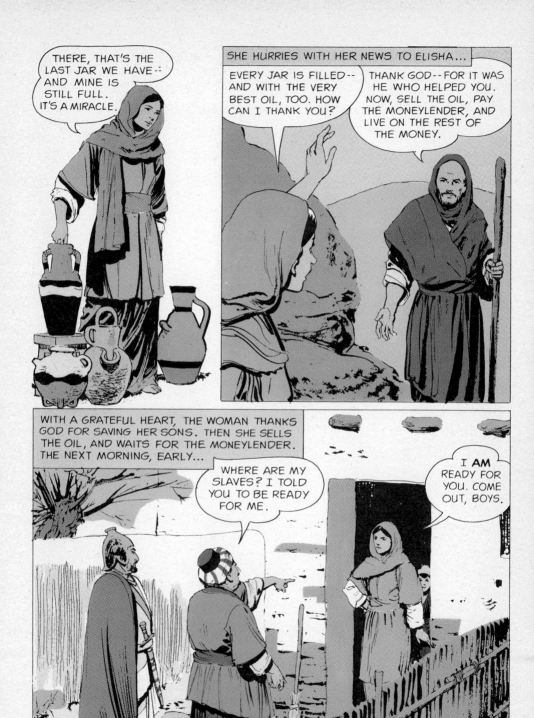

11

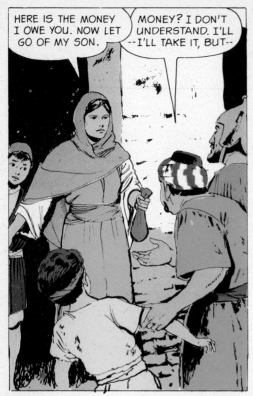

HERE IS THE MONEY I OWE YOU. NOW LET GO OF MY SON.

MONEY? I DON'T UNDERSTAND. I'LL --I'LL TAKE IT, BUT--

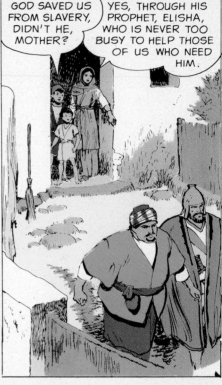

GOD SAVED US FROM SLAVERY, DIDN'T HE, MOTHER?

YES, THROUGH HIS PROPHET, ELISHA, WHO IS NEVER TOO BUSY TO HELP THOSE OF US WHO NEED HIM.

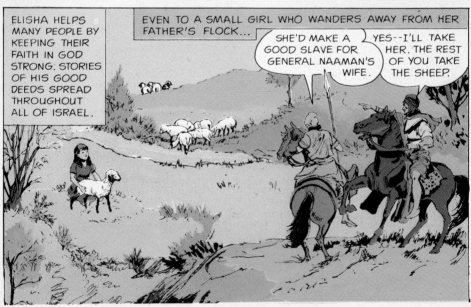

ELISHA HELPS MANY PEOPLE BY KEEPING THEIR FAITH IN GOD STRONG. STORIES OF HIS GOOD DEEDS SPREAD THROUGHOUT ALL OF ISRAEL.

EVEN TO A SMALL GIRL WHO WANDERS AWAY FROM HER FATHER'S FLOCK...

SHE'D MAKE A GOOD SLAVE FOR GENERAL NAAMAN'S WIFE.

YES--I'LL TAKE HER. THE REST OF YOU TAKE THE SHEEP.

A Prophet's Prescription

FROM II Kings 5: 1-14a

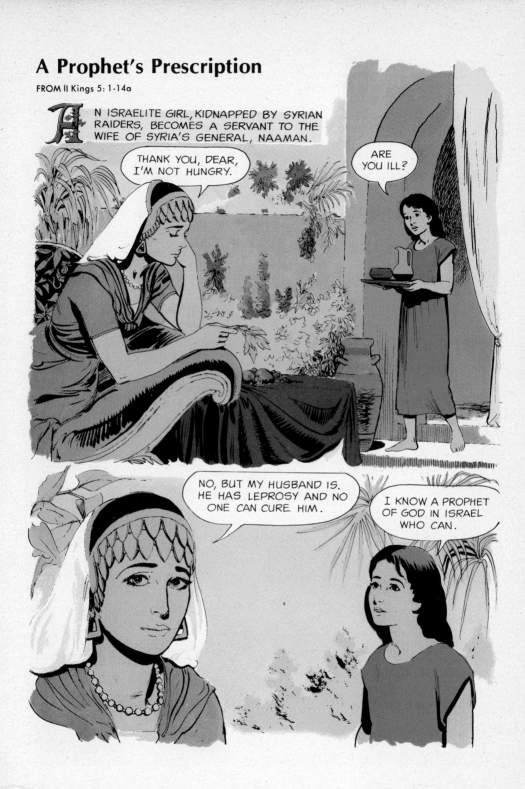

AN ISRAELITE GIRL, KIDNAPPED BY SYRIAN RAIDERS, BECOMES A SERVANT TO THE WIFE OF SYRIA'S GENERAL, NAAMAN.

THANK YOU, DEAR, I'M NOT HUNGRY.

ARE YOU ILL?

NO, BUT MY HUSBAND IS. HE HAS LEPROSY AND NO ONE CAN CURE HIM.

I KNOW A PROPHET OF GOD IN ISRAEL WHO CAN.

NAAMAN'S WIFE BELIEVES THE GIRL AND RUNS TO TELL HER HUSBAND. NAAMAN QUICKLY TAKES THE NEWS TO THE KING.

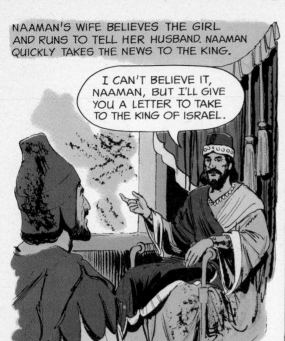

I CAN'T BELIEVE IT, NAAMAN, BUT I'LL GIVE YOU A LETTER TO TAKE TO THE KING OF ISRAEL.

IN SAMARIA, THE CAPITAL OF ISRAEL, NAAMAN HAS THE LETTER DELIVERED TO KING JEHORAM. THE LETTER DOES NOT MENTION ELISHA, SO THE KING MISINTERPRETS IT.

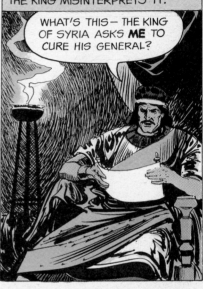

WHAT'S THIS—THE KING OF SYRIA ASKS **ME** TO CURE HIS GENERAL?

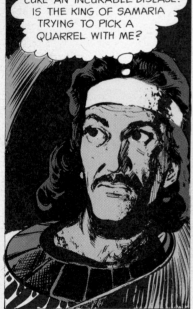

AM I A GOD THAT I CAN CURE AN INCURABLE DISEASE? IS THE KING OF SAMARIA TRYING TO PICK A QUARREL WITH ME?

REPORTS OF KING JEHORAM'S PROBLEM SPREAD THROUGHOUT THE CITY. WHEN ELISHA HEARS THEM HE SENDS HIS SERVANT TO THE KING.

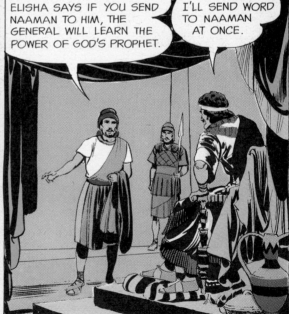

ELISHA SAYS IF YOU SEND NAAMAN TO HIM, THE GENERAL WILL LEARN THE POWER OF GOD'S PROPHET.

I'LL SEND WORD TO NAAMAN AT ONCE.

NAAMAN LOSES NO TIME IN GOING TO ELISHA'S HOUSE WHERE HE IS MET BY A SERVANT.

GREETINGS, NAAMAN. ELISHA SAYS THAT IF YOU WILL WASH SEVEN TIMES IN THE JORDAN RIVER YOU WILL BE CURED.

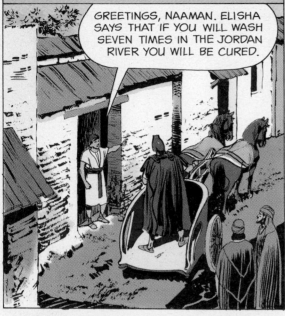

WASH IN THE JORDAN? THAT'S SILLY! I THOUGHT ELISHA WOULD CALL ON HIS GOD TO CURE ME.

NAAMAN THINKS HE HAS BEEN MADE A FOOL OF-- AND IN A RAGE HE DRIVES AWAY.

THINK AGAIN, NAAMAN. IF ELISHA HAD ASKED YOU TO DO SOMETHING HARD, YOU WOULD HAVE DONE IT. WHY NOT DO THIS EASY THING HE ASKS?

THE GENERAL TAKES HIS SERVANT'S ADVICE AND GOES TO THE JORDAN RIVER.

I DON'T SEE HOW THIS MUDDY WATER WILL CURE LEPROSY.

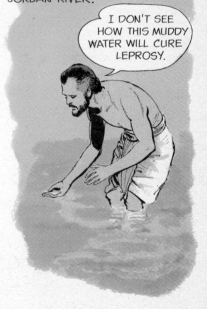

15

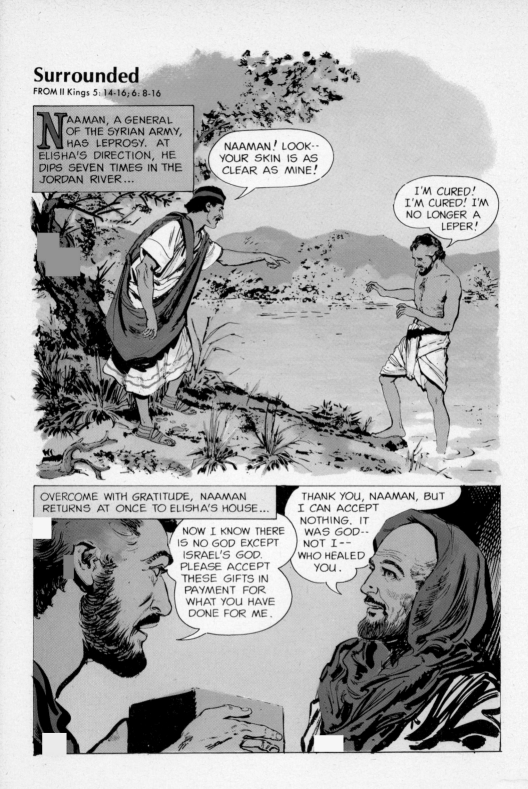

Surrounded
FROM II Kings 5: 14-16; 6: 8-16

NAAMAN, A GENERAL OF THE SYRIAN ARMY, HAS LEPROSY. AT ELISHA'S DIRECTION, HE DIPS SEVEN TIMES IN THE JORDAN RIVER...

NAAMAN! LOOK-- YOUR SKIN IS AS CLEAR AS MINE!

I'M CURED! I'M CURED! I'M NO LONGER A LEPER!

OVERCOME WITH GRATITUDE, NAAMAN RETURNS AT ONCE TO ELISHA'S HOUSE...

NOW I KNOW THERE IS NO GOD EXCEPT ISRAEL'S GOD. PLEASE ACCEPT THESE GIFTS IN PAYMENT FOR WHAT YOU HAVE DONE FOR ME.

THANK YOU, NAAMAN, BUT I CAN ACCEPT NOTHING. IT WAS GOD-- NOT I-- WHO HEALED YOU.

THEN NAAMAN RETURNS TO HIS HOME IN SYRIA.

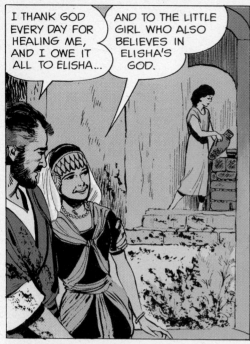

I THANK GOD EVERY DAY FOR HEALING ME, AND I OWE IT ALL TO ELISHA...

AND TO THE LITTLE GIRL WHO ALSO BELIEVES IN ELISHA'S GOD.

BUT THE HEALING OF NAAMAN DOES NOT KEEP THE KING OF SYRIA FROM PLOTTING AGAINST ISRAEL.

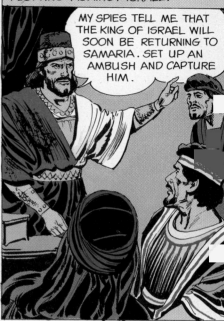

MY SPIES TELL ME THAT THE KING OF ISRAEL WILL SOON BE RETURNING TO SAMARIA. SET UP AN AMBUSH AND CAPTURE HIM.

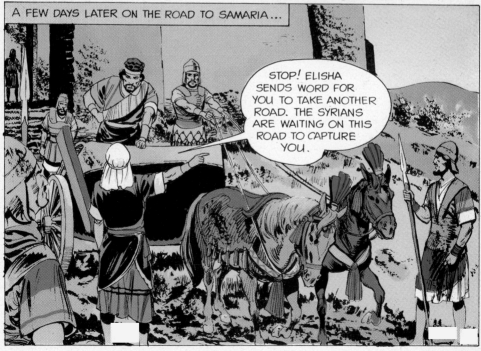

A FEW DAYS LATER ON THE ROAD TO SAMARIA...

STOP! ELISHA SENDS WORD FOR YOU TO TAKE ANOTHER ROAD. THE SYRIANS ARE WAITING ON THIS ROAD TO CAPTURE YOU.

FOR DAYS THE SYRIAN SOLDIERS WAIT FOR THE ISRAELITE KING -- BUT HE DOESN'T COME. AGAIN THE SYRIAN KING SETS A TRAP AND AGAIN ELISHA WARNS HIS KING TO ESCAPE. FINALLY THE SYRIAN KING BECOMES SO ANGRY THAT HE ACCUSES HIS OWN MEN OF TREASON.

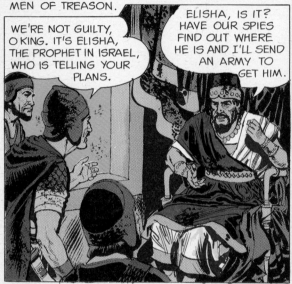

WE'RE NOT GUILTY, O KING. IT'S ELISHA, THE PROPHET IN ISRAEL, WHO IS TELLING YOUR PLANS.

ELISHA, IS IT? HAVE OUR SPIES FIND OUT WHERE HE IS AND I'LL SEND AN ARMY TO GET HIM.

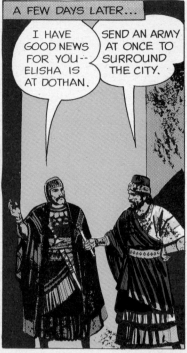

A FEW DAYS LATER...

I HAVE GOOD NEWS FOR YOU -- ELISHA IS AT DOTHAN.

SEND AN ARMY AT ONCE TO SURROUND THE CITY.

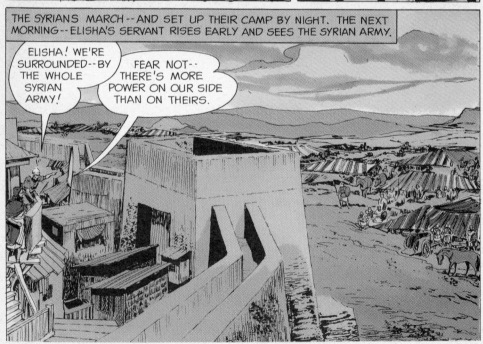

THE SYRIANS MARCH -- AND SET UP THEIR CAMP BY NIGHT. THE NEXT MORNING -- ELISHA'S SERVANT RISES EARLY AND SEES THE SYRIAN ARMY.

ELISHA! WE'RE SURROUNDED -- BY THE WHOLE SYRIAN ARMY!

FEAR NOT -- THERE'S MORE POWER ON OUR SIDE THAN ON THEIRS.

One Against an Army

FROM II Kings 6: 17-25—7: 5

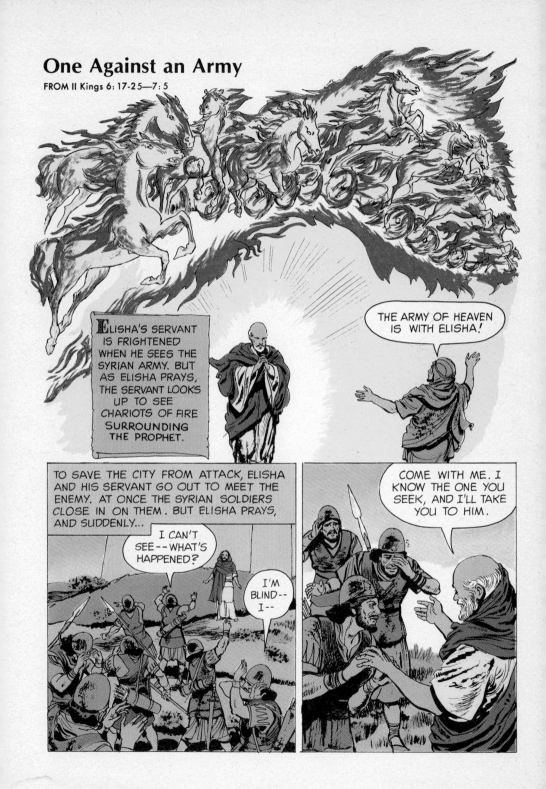

ELISHA'S SERVANT IS FRIGHTENED WHEN HE SEES THE SYRIAN ARMY. BUT AS ELISHA PRAYS, THE SERVANT LOOKS UP TO SEE CHARIOTS OF FIRE SURROUNDING THE PROPHET.

THE ARMY OF HEAVEN IS WITH ELISHA!

TO SAVE THE CITY FROM ATTACK, ELISHA AND HIS SERVANT GO OUT TO MEET THE ENEMY. AT ONCE THE SYRIAN SOLDIERS CLOSE IN ON THEM. BUT ELISHA PRAYS, AND SUDDENLY...

I CAN'T SEE--WHAT'S HAPPENED?

I'M BLIND-- I--

COME WITH ME. I KNOW THE ONE YOU SEEK, AND I'LL TAKE YOU TO HIM.

19

ELISHA LEADS THE ENEMY SOLDIERS TEN MILES SOUTH AND INTO THE CAPITAL CITY OF ISRAEL.

O LORD, OPEN THEIR EYES, THAT THEY MAY SEE.

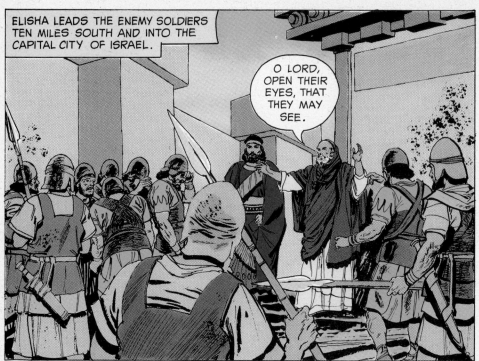

INSTANTLY, SIGHT RETURNS TO THE SYRIANS.

WE'RE IN SAMARIA--

WE'RE TRAPPED-- THEY'LL KILL US!

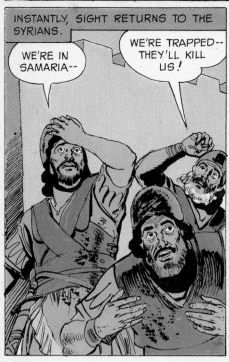

SHALL WE KILL THEM, ELISHA?

NO. FEED THEM AND SEND THEM HOME.

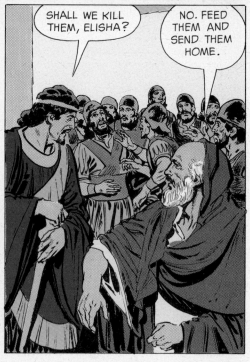

TO THE AMAZEMENT OF THE SYRIANS, THEY ARE GIVEN FOOD AND TOLD TO RETURN HOME.

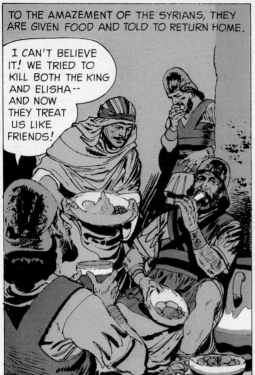

I CAN'T BELIEVE IT! WE TRIED TO KILL BOTH THE KING AND ELISHA-- AND NOW THEY TREAT US LIKE FRIENDS!

BACK HOME, THE SYRIANS TELL ABOUT THE KINDNESS OF THE ISRAELITES, AND FOR A TIME THERE IS PEACE BETWEEN THE TWO NATIONS. BUT AFTER A WHILE...

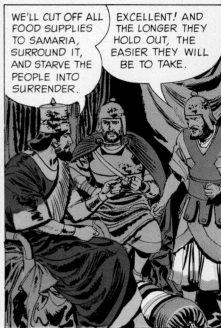

WE'LL CUT OFF ALL FOOD SUPPLIES TO SAMARIA, SURROUND IT, AND STARVE THE PEOPLE INTO SURRENDER.

EXCELLENT! AND THE LONGER THEY HOLD OUT, THE EASIER THEY WILL BE TO TAKE.

SO THE SYRIAN ARMY PITCHES ITS TENTS AROUND THE WALLS OF SAMARIA AND WAITS...

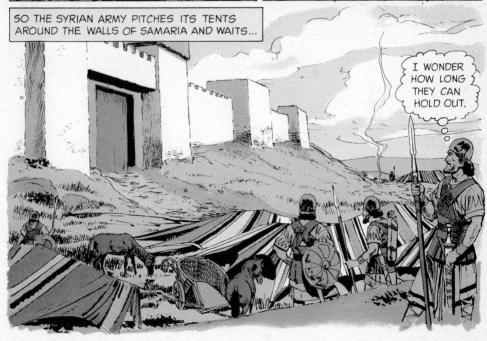

I WONDER HOW LONG THEY CAN HOLD OUT.

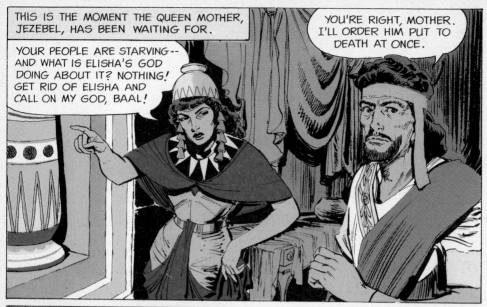

THIS IS THE MOMENT THE QUEEN MOTHER, JEZEBEL, HAS BEEN WAITING FOR.

YOUR PEOPLE ARE STARVING-- AND WHAT IS ELISHA'S GOD DOING ABOUT IT? NOTHING! GET RID OF ELISHA AND CALL ON MY GOD, BAAL!

YOU'RE RIGHT, MOTHER. I'LL ORDER HIM PUT TO DEATH AT ONCE.

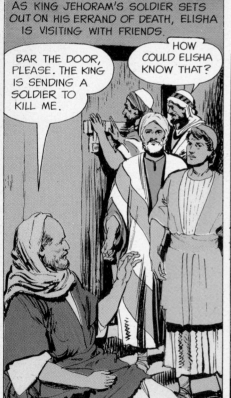

AS KING JEHORAM'S SOLDIER SETS OUT ON HIS ERRAND OF DEATH, ELISHA IS VISITING WITH FRIENDS.

BAR THE DOOR, PLEASE. THE KING IS SENDING A SOLDIER TO KILL ME.

HOW COULD ELISHA KNOW THAT?

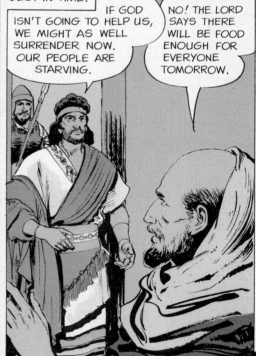

BUT THE KING SUDDENLY BECOMES WORRIED ABOUT KILLING THE PROPHET. HE RUSHES AFTER HIS SOLDIER, AND REACHES ELISHA JUST IN TIME.

IF GOD ISN'T GOING TO HELP US, WE MIGHT AS WELL SURRENDER NOW. OUR PEOPLE ARE STARVING.

NO! THE LORD SAYS THERE WILL BE FOOD ENOUGH FOR EVERYONE TOMORROW.

THE ANXIOUS KING IS WILLING TO WAIT UNTIL THE NEXT DAY, BUT OUTSIDE THE CITY FOUR LEPERS HAVE NOT HEARD ELISHA'S PROPHECY...

I'M STARVING. I'M GOING TO TRY TO BREAK INTO THE CITY AND GET SOME FOOD.

WHY DO THAT? THERE'S NO FOOD IN THERE.

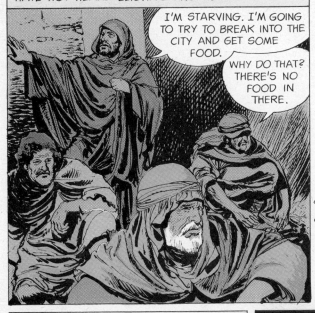

THEN LET'S GO OVER TO THE SYRIAN CAMP. MAYBE THEY'LL GIVE US SOMETHING TO EAT. MAYBE THEY'LL KILL US. EITHER WAY, THERE'S NOTHING TO LOSE—WE'LL STARVE IF WE STAY HERE.

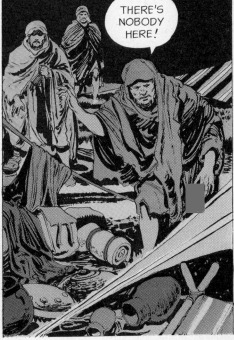

IN DESPERATION THE FOUR HUNGRY LEPERS APPROACH THE SYRIAN CAMP.

SOMETHING STRANGE IS GOING ON. THERE'S NOT A GUARD IN SIGHT. MAYBE IT'S A TRAP—

MAYBE IT IS—BUT I'D RATHER DIE QUICKLY THAN STARVE TO DEATH. COME ON—

THERE'S NOBODY HERE!

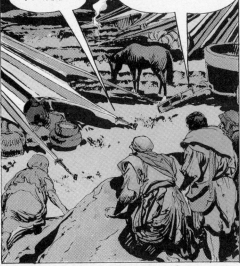

The Missing Enemy

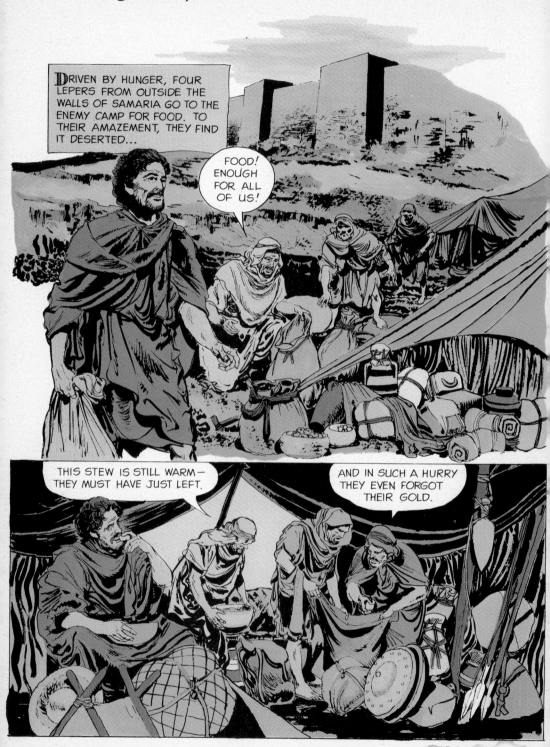

THEIR HUNGER SATISFIED, THE LEPERS QUICKLY SEARCH THE SYRIAN TENTS.

MORE GOLD -- WE'RE RICH!

LOOK! WON'T PEOPLE BE SURPRISED TO SEE ME IN THIS?

SURPRISED? THEY'LL SAY YOU STOLE IT. THEN YOU'LL REALLY BE IN TROUBLE.

HE'S RIGHT -- LET'S HIDE EVERYTHING.

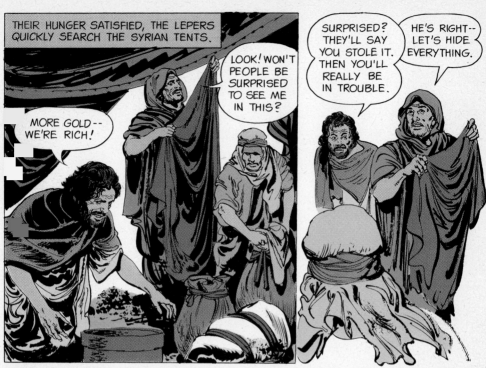

IT ISN'T RIGHT FOR US TO KEEP ALL OF THIS FOOD FROM THE STARVING PEOPLE IN THE CITY.

IF WE DON'T TELL THE GOOD NEWS, SOME PUNISHMENT MAY COME UPON US.

THE MEN GO BACK TO THE CITY AND POUND ON THE GATES UNTIL A GUARD ANSWERS.

THE SYRIANS ARE GONE!

GONE? WHERE? HOW DO YOU KNOW?

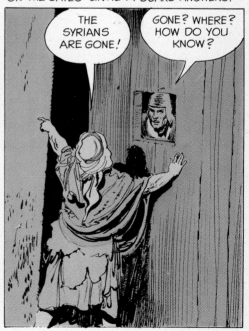

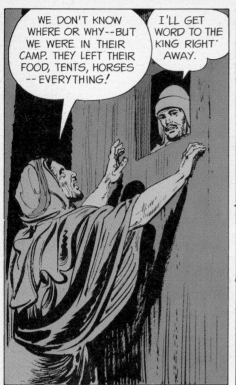

WE DON'T KNOW WHERE OR WHY--BUT WE WERE IN THEIR CAMP. THEY LEFT THEIR FOOD, TENTS, HORSES --EVERYTHING!

I'LL GET WORD TO THE KING RIGHT AWAY.

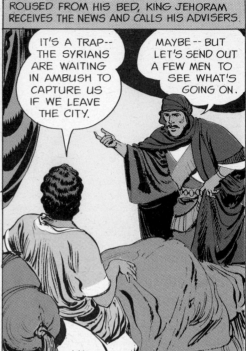

ROUSED FROM HIS BED, KING JEHORAM RECEIVES THE NEWS AND CALLS HIS ADVISERS.

IT'S A TRAP-- THE SYRIANS ARE WAITING IN AMBUSH TO CAPTURE US IF WE LEAVE THE CITY.

MAYBE--BUT LET'S SEND OUT A FEW MEN TO SEE WHAT'S GOING ON.

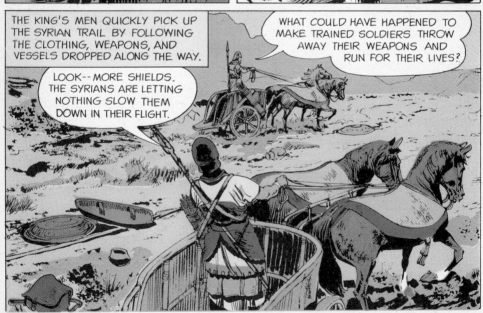

THE KING'S MEN QUICKLY PICK UP THE SYRIAN TRAIL BY FOLLOWING THE CLOTHING, WEAPONS, AND VESSELS DROPPED ALONG THE WAY.

WHAT COULD HAVE HAPPENED TO MAKE TRAINED SOLDIERS THROW AWAY THEIR WEAPONS AND RUN FOR THEIR LIVES?

LOOK--MORE SHIELDS. THE SYRIANS ARE LETTING NOTHING SLOW THEM DOWN IN THEIR FLIGHT.

The Sound of Marching Men

FROM II KINGS 7: 14—9: 12

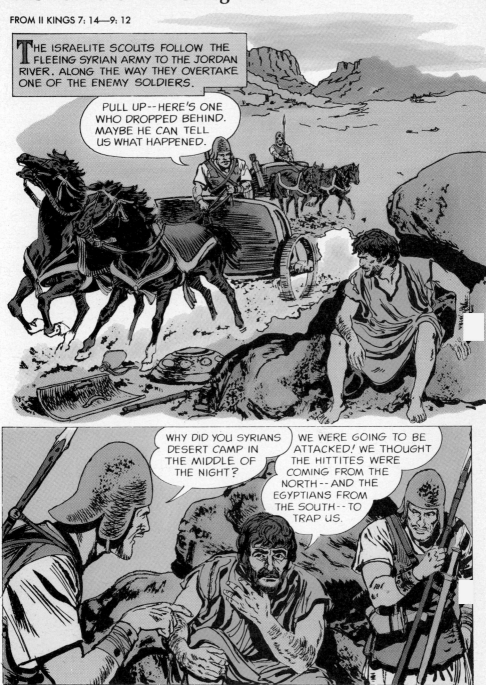

WE RODE AROUND YOUR CAMP. THERE WAS NO SIGN OF EVEN A SCOUTING PARTY-- LET ALONE **TWO** ARMIES. DID YOU REALLY **SEE** THEM?

NO--BUT WE HEARD THEM! THOUSANDS OF SOLDIERS, HORSES AND CHARIOTS -- WE WOULDN'T HAVE HAD A CHANCE AGAINST SUCH MIGHT.

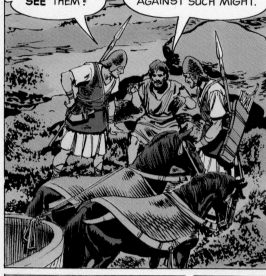

THE **SOUND** OF ARMIES -- REAL ENOUGH TO FRIGHTEN THE WHOLE SYRIAN CAMP. WHAT DO YOU MAKE OF IT?

IT WAS A MIRACLE--USED BY ELISHA'S GOD TO FRIGHTEN THE SYRIANS AWAY.

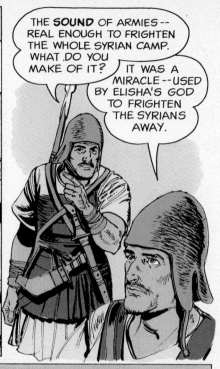

ELISHA'S GOD--YES. THAT FITS IN WITH THE PROMISE THAT BY TODAY THERE WOULD BE FOOD FOR EVERYONE!

BACK IN SAMARIA THE STARVING ISRAELITES RUSH OUT TO THE SYRIAN CAMP, EAT THEIR FILL, AND HAUL THE REST OF THE FOOD BACK TO THE CITY.

YOU SAID THERE WOULD BE FOOD, ELISHA, BUT I DIDN'T BELIEVE YOU.

IT WAS THE LORD WHO PROMISED THE FOOD--AND YOU CAN ALWAYS COUNT ON THE PROMISES OF GOD!

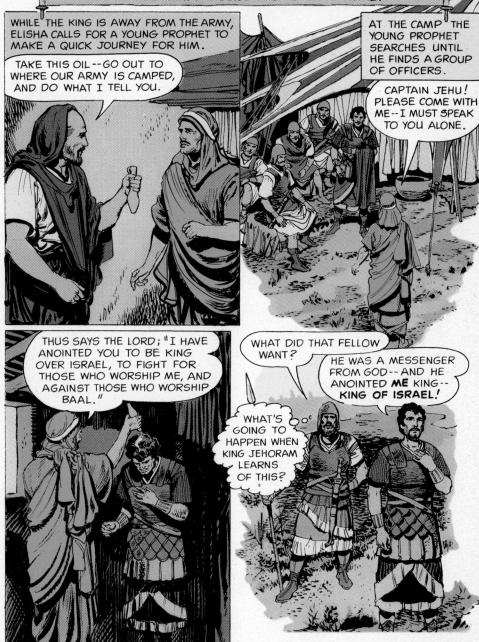

IN SPITE OF THE FACT THAT GOD HAS SAVED ISRAEL, KING JEHORAM AND HIS MOTHER KEEP ON WORSHIPPING BAAL. WHEN ONE OF HIS BORDER CITIES IS ATTACKED BY THE KING OF SYRIA, JEHORAM GOES TO ITS DEFENCE. WOUNDED IN THE BATTLE, HE LEAVES CAPTAIN JEHU IN CHARGE AND RETURNS HOME.

WHILE THE KING IS AWAY FROM THE ARMY, ELISHA CALLS FOR A YOUNG PROPHET TO MAKE A QUICK JOURNEY FOR HIM.

TAKE THIS OIL -- GO OUT TO WHERE OUR ARMY IS CAMPED, AND DO WHAT I TELL YOU.

AT THE CAMP THE YOUNG PROPHET SEARCHES UNTIL HE FINDS A GROUP OF OFFICERS.

CAPTAIN JEHU! PLEASE COME WITH ME -- I MUST SPEAK TO YOU ALONE.

THUS SAYS THE LORD; "I HAVE ANOINTED YOU TO BE KING OVER ISRAEL, TO FIGHT FOR THOSE WHO WORSHIP ME, AND AGAINST THOSE WHO WORSHIP BAAL."

WHAT DID THAT FELLOW WANT?

HE WAS A MESSENGER FROM GOD -- AND HE ANOINTED **ME** KING -- **KING OF ISRAEL!**

WHAT'S GOING TO HAPPEN WHEN KING JEHORAM LEARNS OF THIS?

Revenge of Israel

FROM II KINGS 9: 13-32

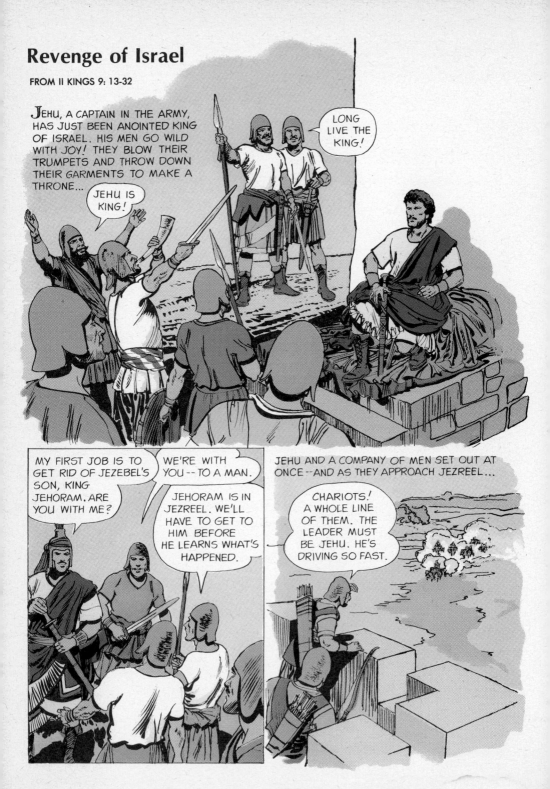

JEHU, A CAPTAIN IN THE ARMY, HAS JUST BEEN ANOINTED KING OF ISRAEL. HIS MEN GO WILD WITH JOY! THEY BLOW THEIR TRUMPETS AND THROW DOWN THEIR GARMENTS TO MAKE A THRONE...

LONG LIVE THE KING!

JEHU IS KING!

MY FIRST JOB IS TO GET RID OF JEZEBEL'S SON, KING JEHORAM. ARE YOU WITH ME?

WE'RE WITH YOU -- TO A MAN.

JEHORAM IS IN JEZREEL. WE'LL HAVE TO GET TO HIM BEFORE HE LEARNS WHAT'S HAPPENED.

JEHU AND A COMPANY OF MEN SET OUT AT ONCE--AND AS THEY APPROACH JEZREEL...

CHARIOTS! A WHOLE LINE OF THEM. THE LEADER MUST BE JEHU. HE'S DRIVING SO FAST.

WHEN THE NEWS REACHES KING JEHORAM, HE BELIEVES JEHU IS BRINGING NEWS OF THE WAR. SO, WITH HIS VISITOR, KING AHAZIAH OF JUDAH, HE RIDES OUT TO MEET JEHU.

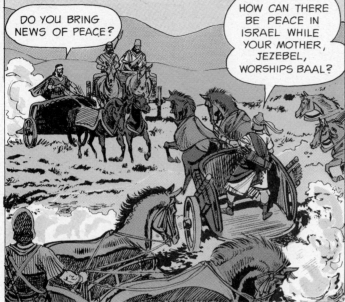

DO YOU BRING NEWS OF PEACE?

HOW CAN THERE BE PEACE IN ISRAEL WHILE YOUR MOTHER, JEZEBEL, WORSHIPS BAAL?

TOO LATE, JEHORAM SEES THAT JEHU HAS COME TO OVERTHROW THE KINGDOM. HE TRIES TO ESCAPE, BUT JEHU'S ARROW STRIKES HIM DOWN.

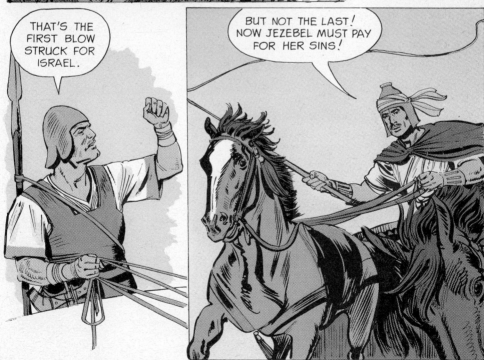

THAT'S THE FIRST BLOW STRUCK FOR ISRAEL.

BUT NOT THE LAST! NOW JEZEBEL MUST PAY FOR HER SINS!

A Queen's Plot

FROM II Kings 9:32—11:3

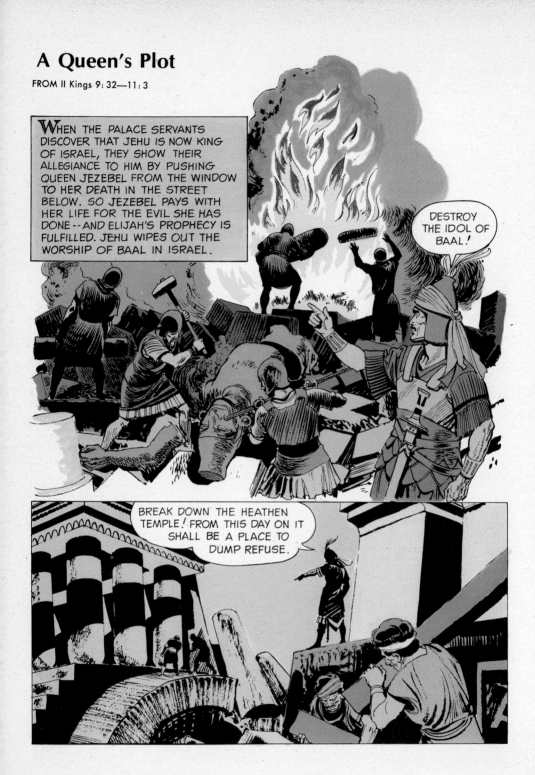

WHEN THE PALACE SERVANTS DISCOVER THAT JEHU IS NOW KING OF ISRAEL, THEY SHOW THEIR ALLEGIANCE TO HIM BY PUSHING QUEEN JEZEBEL FROM THE WINDOW TO HER DEATH IN THE STREET BELOW. SO JEZEBEL PAYS WITH HER LIFE FOR THE EVIL SHE HAS DONE -- AND ELIJAH'S PROPHECY IS FULFILLED. JEHU WIPES OUT THE WORSHIP OF BAAL IN ISRAEL.

DESTROY THE IDOL OF BAAL!

BREAK DOWN THE HEATHEN TEMPLE! FROM THIS DAY ON IT SHALL BE A PLACE TO DUMP REFUSE.

TO THE SOUTH, IN THE KINGDOM OF JUDAH, JEZEBEL'S DAUGHTER, ATHALIAH, RECEIVES THE NEWS...

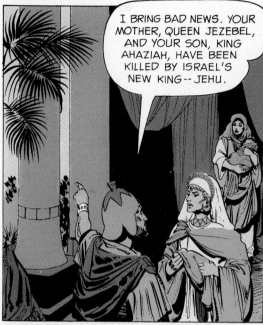

I BRING BAD NEWS. YOUR MOTHER, QUEEN JEZEBEL, AND YOUR SON, KING AHAZIAH, HAVE BEEN KILLED BY ISRAEL'S NEW KING -- JEHU.

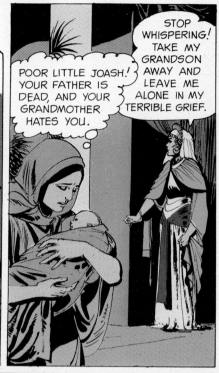

POOR LITTLE JOASH! YOUR FATHER IS DEAD, AND YOUR GRANDMOTHER HATES YOU.

STOP WHISPERING! TAKE MY GRANDSON AWAY AND LEAVE ME ALONE IN MY TERRIBLE GRIEF.

BUT ATHALIAH'S GRIEF IS ONLY A COVER FOR HER PLAN.

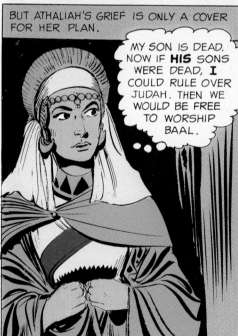

MY SON IS DEAD. NOW IF **HIS** SONS WERE DEAD, **I** COULD RULE OVER JUDAH. THEN WE WOULD BE FREE TO WORSHIP BAAL.

SHE ACTS AT ONCE TO CARRY OUT HER BOLD PLOT.

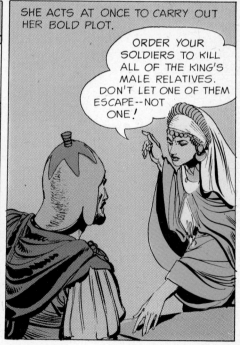

ORDER YOUR SOLDIERS TO KILL ALL OF THE KING'S MALE RELATIVES. DON'T LET ONE OF THEM ESCAPE -- NOT ONE!

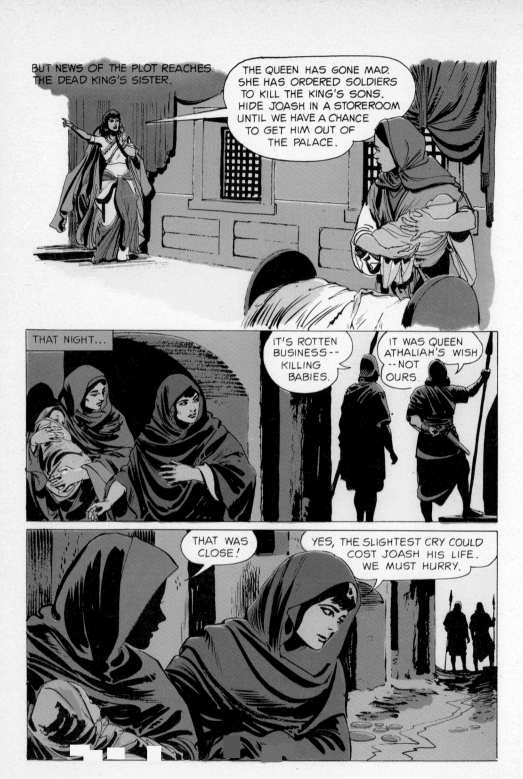

BUT NEWS OF THE PLOT REACHES THE DEAD KING'S SISTER.

THE QUEEN HAS GONE MAD. SHE HAS ORDERED SOLDIERS TO KILL THE KING'S SONS. HIDE JOASH IN A STOREROOM UNTIL WE HAVE A CHANCE TO GET HIM OUT OF THE PALACE.

THAT NIGHT...

IT'S ROTTEN BUSINESS -- KILLING BABIES.

IT WAS QUEEN ATHALIAH'S WISH -- NOT OURS.

THAT WAS CLOSE!

YES, THE SLIGHTEST CRY COULD COST JOASH HIS LIFE. WE MUST HURRY.

The Temple Secret

FROM II Kings 11: 1-12

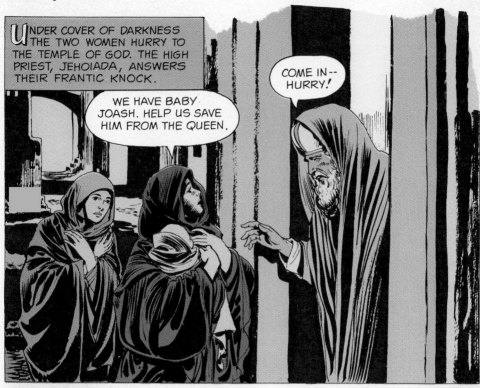

UNDER COVER OF DARKNESS THE TWO WOMEN HURRY TO THE TEMPLE OF GOD. THE HIGH PRIEST, JEHOIADA, ANSWERS THEIR FRANTIC KNOCK.

WE HAVE BABY JOASH. HELP US SAVE HIM FROM THE QUEEN.

COME IN-- HURRY!

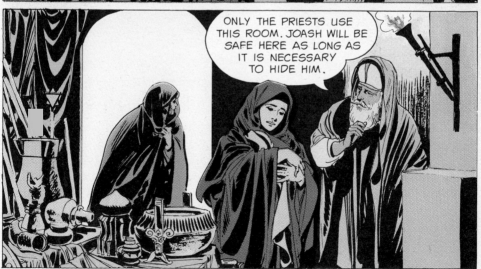

ONLY THE PRIESTS USE THIS ROOM. JOASH WILL BE SAFE HERE AS LONG AS IT IS NECESSARY TO HIDE HIM.

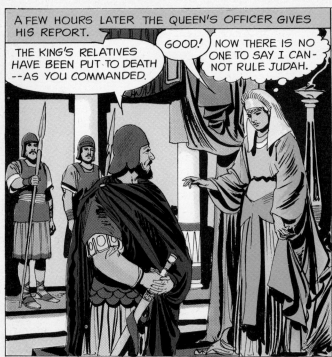

A FEW HOURS LATER THE QUEEN'S OFFICER GIVES HIS REPORT.

THE KING'S RELATIVES HAVE BEEN PUT·TO DEATH --AS YOU COMMANDED.

GOOD!

NOW THERE IS NO ONE TO SAY I CAN-NOT RULE JUDAH.

FOR SIX YEARS ATHALIAH RULES JUDAH WITH A CRUEL HAND UNTIL AT LAST THE PEOPLE BEGIN TO COMPLAIN. UNKNOWN TO THEM --IN A SECRET ROOM OF THE TEMPLE--YOUNG PRINCE JOASH IS BEING TRAINED BY THE HIGH PRIEST.

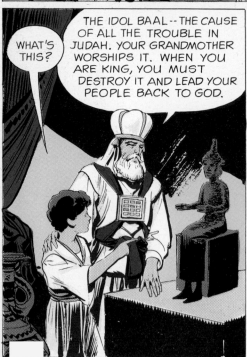

WHAT'S THIS?

THE IDOL BAAL--THE CAUSE OF ALL THE TROUBLE IN JUDAH. YOUR GRANDMOTHER WORSHIPS IT. WHEN YOU ARE KING, YOU MUST DESTROY IT AND LEAD YOUR PEOPLE BACK TO GOD.

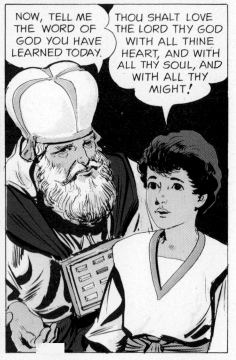

NOW, TELL ME THE WORD OF GOD YOU HAVE LEARNED TODAY.

THOU SHALT LOVE THE LORD THY GOD WITH ALL THINE HEART, AND WITH ALL THY SOUL, AND WITH ALL THY MIGHT!

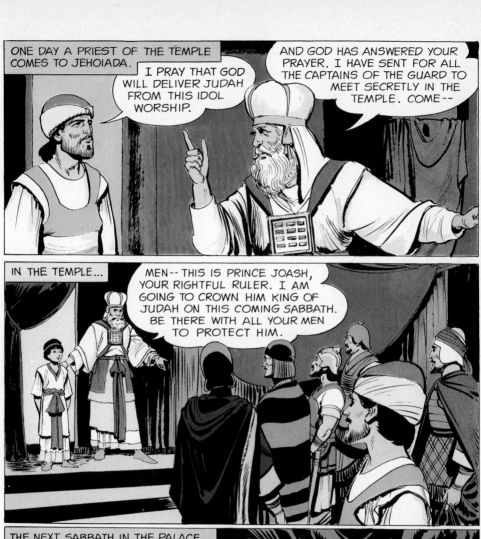

ONE DAY A PRIEST OF THE TEMPLE COMES TO JEHOIADA.

I PRAY THAT GOD WILL DELIVER JUDAH FROM THIS IDOL WORSHIP.

AND GOD HAS ANSWERED YOUR PRAYER. I HAVE SENT FOR ALL THE CAPTAINS OF THE GUARD TO MEET SECRETLY IN THE TEMPLE. COME--

IN THE TEMPLE...

MEN-- THIS IS PRINCE JOASH, YOUR RIGHTFUL RULER. I AM GOING TO CROWN HIM KING OF JUDAH ON THIS COMING SABBATH. BE THERE WITH ALL YOUR MEN TO PROTECT HIM.

THE NEXT SABBATH IN THE PALACE...

THE SOUND OF CHEERING --IT COMES FROM THE TEMPLE. I WONDER WHAT IT MEANS!

Boy King of Judah

FROM II KINGS 11: 13-21; II CHRONICLES 24: 1-23

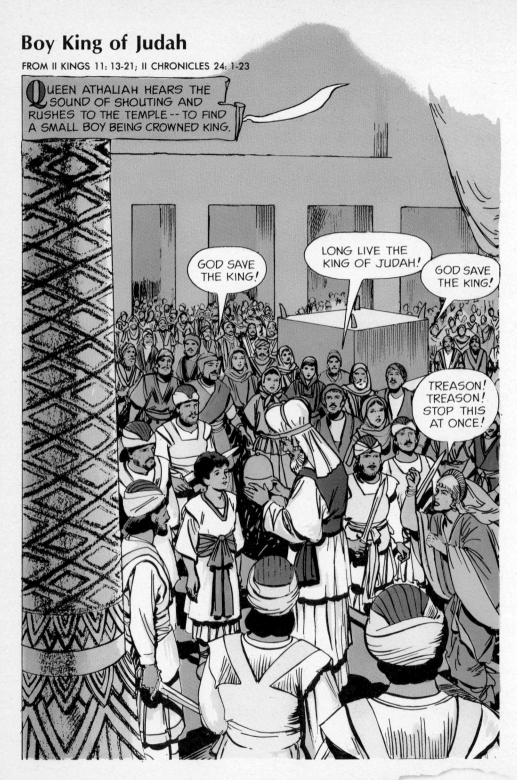

QUEEN ATHALIAH HEARS THE SOUND OF SHOUTING AND RUSHES TO THE TEMPLE -- TO FIND A SMALL BOY BEING CROWNED KING.

GOD SAVE THE KING!

LONG LIVE THE KING OF JUDAH!

GOD SAVE THE KING!

TREASON! TREASON! STOP THIS AT ONCE!

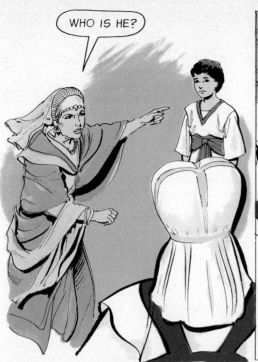

WHO IS HE?

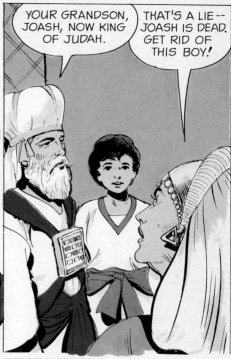

YOUR GRANDSON, JOASH, NOW KING OF JUDAH.

THAT'S A LIE-- JOASH IS DEAD. GET RID OF THIS BOY!

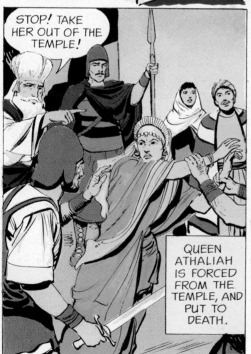

STOP! TAKE HER OUT OF THE TEMPLE!

QUEEN ATHALIAH IS FORCED FROM THE TEMPLE, AND PUT TO DEATH.

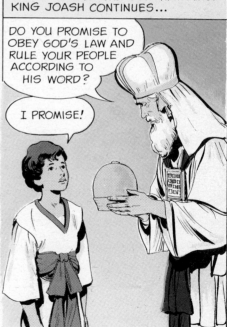

IN THE TEMPLE THE CORONATION OF KING JOASH CONTINUES...

DO YOU PROMISE TO OBEY GOD'S LAW AND RULE YOUR PEOPLE ACCORDING TO HIS WORD?

I PROMISE!

UNDER THE GUIDANCE OF JEHOIADA, THE HIGH PRIEST, JOASH DESTROYS THE TEMPLE OF BAAL AND LEADS HIS PEOPLE BACK TO THE WORSHIP OF GOD. THE HOUSE OF GOD IS REPAIRED, AND FOR YEARS JUDAH PROSPERS. BUT WHEN JEHOIADA DIES, JOASH IS TOO WEAK TO STAND UP UNDER THE PRESSURE OF THOSE WHO WOULD TURN HIM AWAY FROM GOD. FINALLY, JEHOIADA'S SON, ZECHARIAH, GOES TO THE KING...

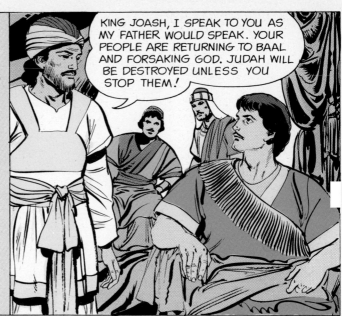

KING JOASH, I SPEAK TO YOU AS MY FATHER WOULD SPEAK. YOUR PEOPLE ARE RETURNING TO BAAL AND FORSAKING GOD. JUDAH WILL BE DESTROYED UNLESS YOU STOP THEM!

AS SOON AS ZECHARIAH LEAVES, THE WORSHIPPERS OF BAAL GIVE THEIR ADVICE.

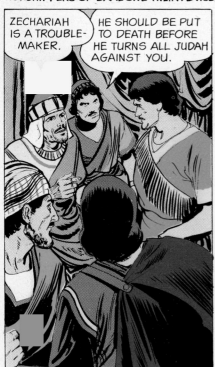

ZECHARIAH IS A TROUBLE-MAKER.

HE SHOULD BE PUT TO DEATH BEFORE HE TURNS ALL JUDAH AGAINST YOU.

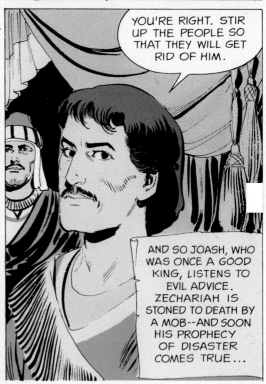

YOU'RE RIGHT. STIR UP THE PEOPLE SO THAT THEY WILL GET RID OF HIM.

AND SO JOASH, WHO WAS ONCE A GOOD KING, LISTENS TO EVIL ADVICE. ZECHARIAH IS STONED TO DEATH BY A MOB--AND SOON HIS PROPHECY OF DISASTER COMES TRUE...

Dagger in the Night

FROM II KINGS 12—18: 10

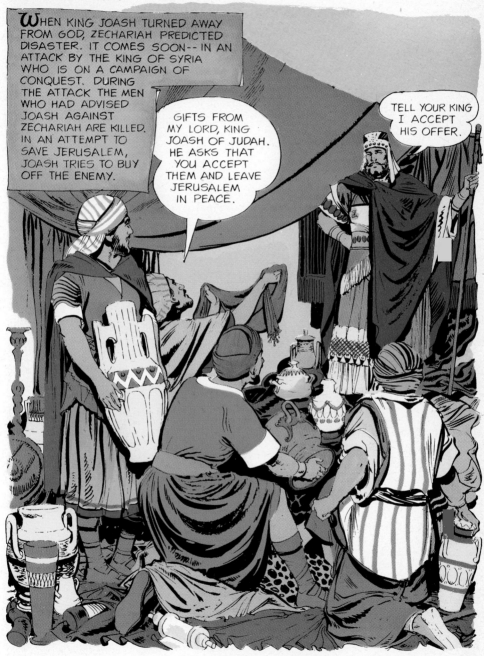

WHEN KING JOASH TURNED AWAY FROM GOD, ZECHARIAH PREDICTED DISASTER. IT COMES SOON-- IN AN ATTACK BY THE KING OF SYRIA WHO IS ON A CAMPAIGN OF CONQUEST. DURING THE ATTACK THE MEN WHO HAD ADVISED JOASH AGAINST ZECHARIAH ARE KILLED. IN AN ATTEMPT TO SAVE JERUSALEM, JOASH TRIES TO BUY OFF THE ENEMY.

GIFTS FROM MY LORD, KING JOASH OF JUDAH. HE ASKS THAT YOU ACCEPT THEM AND LEAVE JERUSALEM IN PEACE.

TELL YOUR KING I ACCEPT HIS OFFER.

HAVING ACQUIRED AN EASY FORTUNE, THE KING OF SYRIA CALLS BACK HIS ARMY AND MARCHES ON. JERUSALEM IS SAVED, BUT JOASH FALLS GRAVELY ILL.

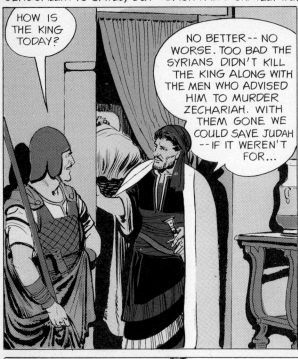

HOW IS THE KING TODAY?

NO BETTER-- NO WORSE. TOO BAD THE SYRIANS DIDN'T KILL THE KING ALONG WITH THE MEN WHO ADVISED HIM TO MURDER ZECHARIAH. WITH THEM GONE WE COULD SAVE JUDAH --IF IT WEREN'T FOR...

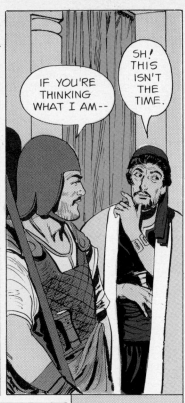

IF YOU'RE THINKING WHAT I AM--

SH! THIS ISN'T THE TIME.

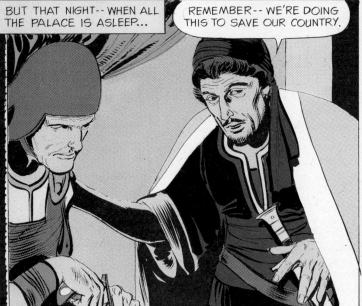

BUT THAT NIGHT-- WHEN ALL THE PALACE IS ASLEEP...

REMEMBER-- WE'RE DOING THIS TO SAVE OUR COUNTRY.

SO KING JOASH IS MURDERED-- BY HIS OWN MEN FOR ALMOST A HUNDRED YEARS JUDAH IS RULED BY KINGS WHO WAVER BETWEEN WORSHIPPING GOD AND HEATHEN IDOLS. THEN HEZEKIAH COMES TO THE THRONE...

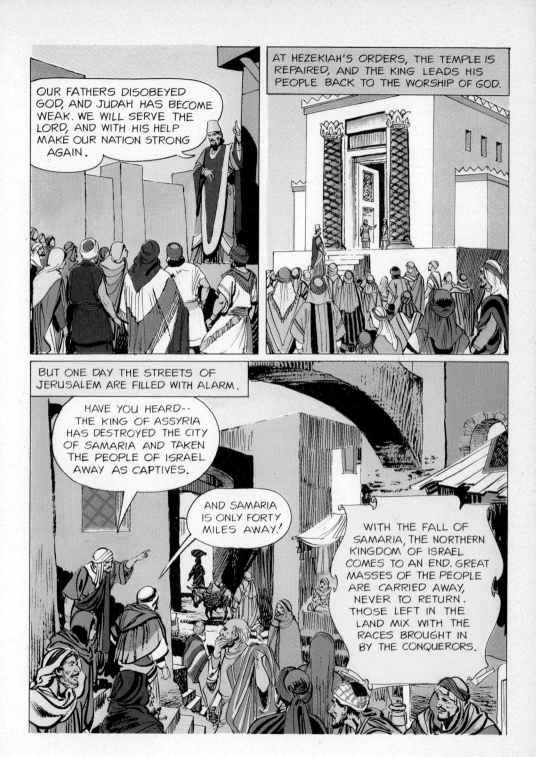

OUR FATHERS DISOBEYED GOD, AND JUDAH HAS BECOME WEAK. WE WILL SERVE THE LORD, AND WITH HIS HELP MAKE OUR NATION STRONG AGAIN.

AT HEZEKIAH'S ORDERS, THE TEMPLE IS REPAIRED, AND THE KING LEADS HIS PEOPLE BACK TO THE WORSHIP OF GOD.

BUT ONE DAY THE STREETS OF JERUSALEM ARE FILLED WITH ALARM.

HAVE YOU HEARD-- THE KING OF ASSYRIA HAS DESTROYED THE CITY OF SAMARIA AND TAKEN THE PEOPLE OF ISRAEL AWAY AS CAPTIVES.

AND SAMARIA IS ONLY FORTY MILES AWAY!

WITH THE FALL OF SAMARIA, THE NORTHERN KINGDOM OF ISRAEL COMES TO AN END. GREAT MASSES OF THE PEOPLE ARE CARRIED AWAY, NEVER TO RETURN. THOSE LEFT IN THE LAND MIX WITH THE RACES BROUGHT IN BY THE CONQUERORS.

Test of a City

FROM II CHRONICLES 32: 1-20

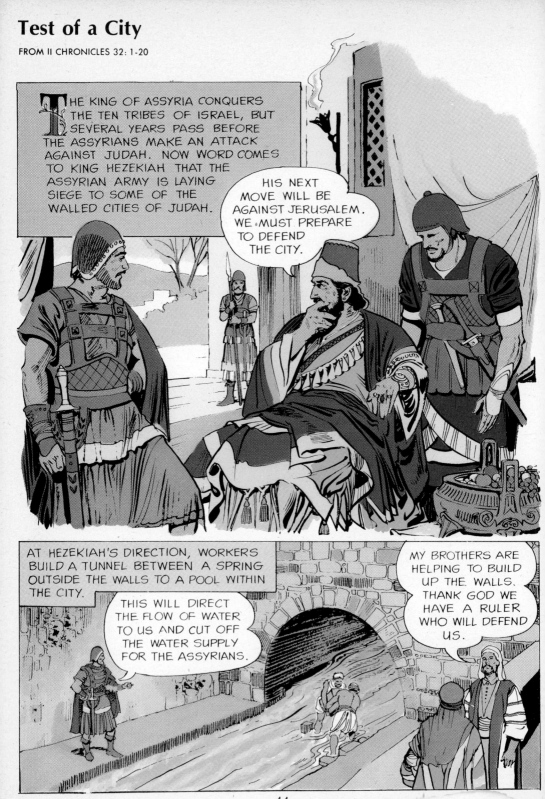

THE KING OF ASSYRIA CONQUERS THE TEN TRIBES OF ISRAEL, BUT SEVERAL YEARS PASS BEFORE THE ASSYRIANS MAKE AN ATTACK AGAINST JUDAH. NOW WORD COMES TO KING HEZEKIAH THAT THE ASSYRIAN ARMY IS LAYING SIEGE TO SOME OF THE WALLED CITIES OF JUDAH.

HIS NEXT MOVE WILL BE AGAINST JERUSALEM. WE MUST PREPARE TO DEFEND THE CITY.

AT HEZEKIAH'S DIRECTION, WORKERS BUILD A TUNNEL BETWEEN A SPRING OUTSIDE THE WALLS TO A POOL WITHIN THE CITY.

THIS WILL DIRECT THE FLOW OF WATER TO US AND CUT OFF THE WATER SUPPLY FOR THE ASSYRIANS.

MY BROTHERS ARE HELPING TO BUILD UP THE WALLS. THANK GOD WE HAVE A RULER WHO WILL DEFEND US.

THEN HEZEKIAH CALLS THE PEOPLE TOGETHER...

DO NOT BE AFRAID. THERE IS MORE POWER ON OUR SIDE THAN ON THE SIDE OF THE ENEMY. THE LORD GOD IS WITH US.

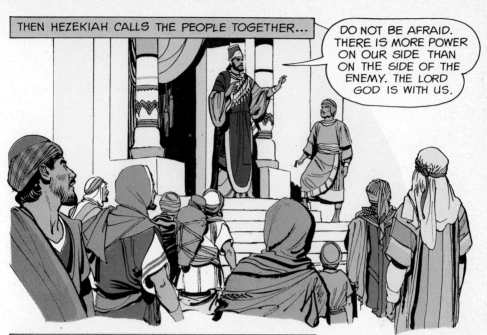

BUT INSTEAD OF MAKING AN ARMED ATTACK ON THE CITY, THE ASSYRIAN KING SENDS A TASK FORCE TO TRY TO FRIGHTEN THE PEOPLE OF JERUSALEM INTO SURRENDERING.

WE HAVE CONQUERED OTHER CITIES AND COUNTRIES. WHAT MAKES YOU THINK YOUR GOD CAN SAVE YOU?

AFTER A WHILE THIS KIND OF ATTACK BEGINS TO HAVE ITS EFFECT.

HOW DO WE KNOW GOD WILL SAVE US?

OTHER CITIES HAVE FALLEN. AND, REMEMBER, IT WAS THE ASSYRIANS WHO TOOK ISRAEL.

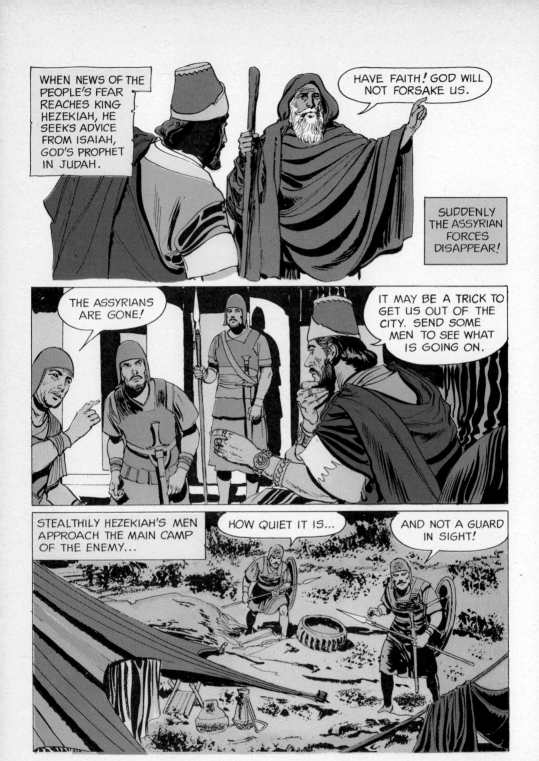

46

A Foolish King

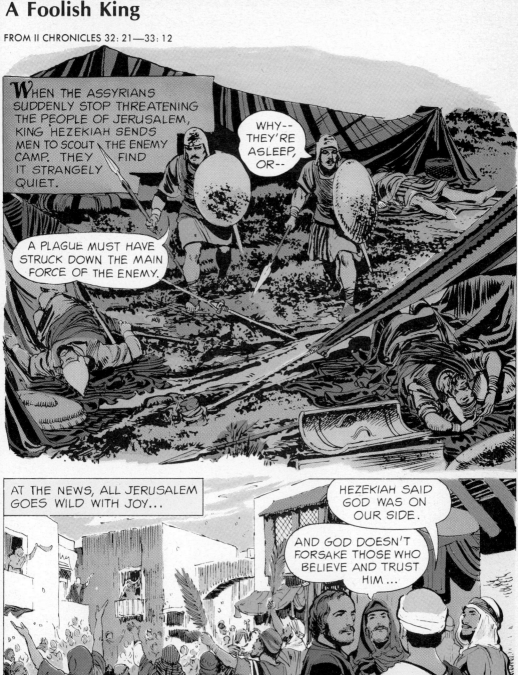

WHEN THE ASSYRIANS SUDDENLY STOP THREATENING THE PEOPLE OF JERUSALEM, KING HEZEKIAH SENDS MEN TO SCOUT THE ENEMY CAMP. THEY FIND IT STRANGELY QUIET.

WHY-- THEY'RE ASLEEP, OR--

A PLAGUE MUST HAVE STRUCK DOWN THE MAIN FORCE OF THE ENEMY.

AT THE NEWS, ALL JERUSALEM GOES WILD WITH JOY...

HEZEKIAH SAID GOD WAS ON OUR SIDE.

AND GOD DOESN'T FORSAKE THOSE WHO BELIEVE AND TRUST HIM ...

47

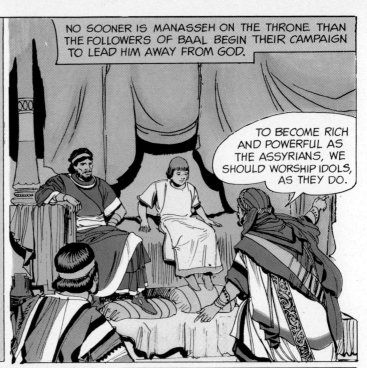

NO SOONER IS MANASSEH ON THE THRONE THAN THE FOLLOWERS OF BAAL BEGIN THEIR CAMPAIGN TO LEAD HIM AWAY FROM GOD.

NEVER AGAIN WHILE HEZEKIAH LIVES DO THE ASSYRIANS TRY TO TAKE JERUSALEM. HEZEKIAH CONTINUES TO LEAD HIS PEOPLE IN THEIR WORSHIP OF GOD, AND THEY ARE HAPPY. AT HIS DEATH, HIS YOUNG SON, MANASSEH, IS CROWNED KING.

TO BECOME RICH AND POWERFUL AS THE ASSYRIANS, WE SHOULD WORSHIP IDOLS, AS THEY DO.

MANASSEH LISTENS TO THEIR ADVICE, AND RESTORES IDOL WORSHIP IN ISRAEL. HE EVEN DARES TO PLACE AN IDOL IN THE TEMPLE OF GOD.

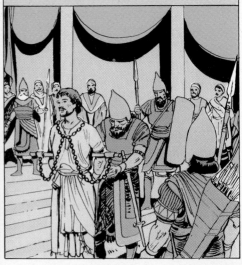

BUT WORSHIPPING THE IDOLS OF THE SURROUNDING NATIONS DOES NOT SAVE MANASSEH. THE ASSYRIAN KING SUSPECTS MANASSEH IS PLOTTING AGAINST HIM AND SENDS TROOPS TO JERUSALEM. IN A SURPRISE MOVE THE ASSYRIANS OVERCOME MANASSEH'S FORCES AND TAKE THE KING PRISONER.

BOUND BY CHAINS, MANASSEH IS PARADED THROUGH THE STREETS OF JERUSALEM...

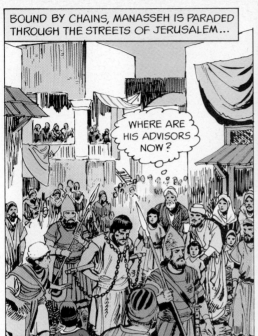

WHERE ARE HIS ADVISORS NOW?

AND IN BABYLON, WHICH IS CONTROLLED BY ASSYRIA, HE IS CAST INTO PRISON.

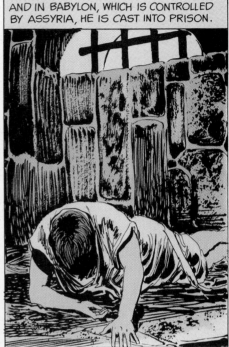

ALONE -- AND IN THE DARKNESS OF HIS CELL -- MANASSEH REVIEWS THE PAST. HE REMEMBERS THAT WHEN HIS FATHER RULED JUDAH, THE ASSYRIANS TRIED TO TAKE JERUSALEM, AND GOD HAD DESTROYED THEM WITH A PLAGUE. ASSYRIA HAD NOT DARED TO STRIKE AGAIN WHILE HIS FATHER LIVED. BUT HIS FATHER HAD OBEYED GOD -- AND HE, MANASSEH...

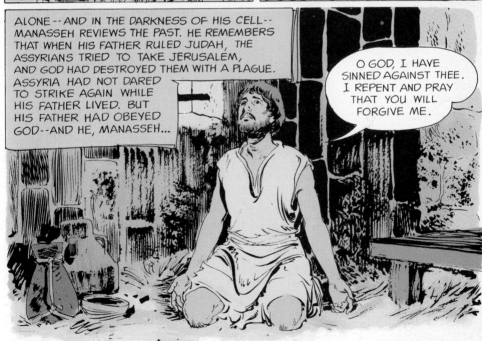

O GOD, I HAVE SINNED AGAINST THEE. I REPENT AND PRAY THAT YOU WILL FORGIVE ME.

The Lost Book

FROM II CHRONICLES 33: 13—34: 18; II KINGS 22: 1-10

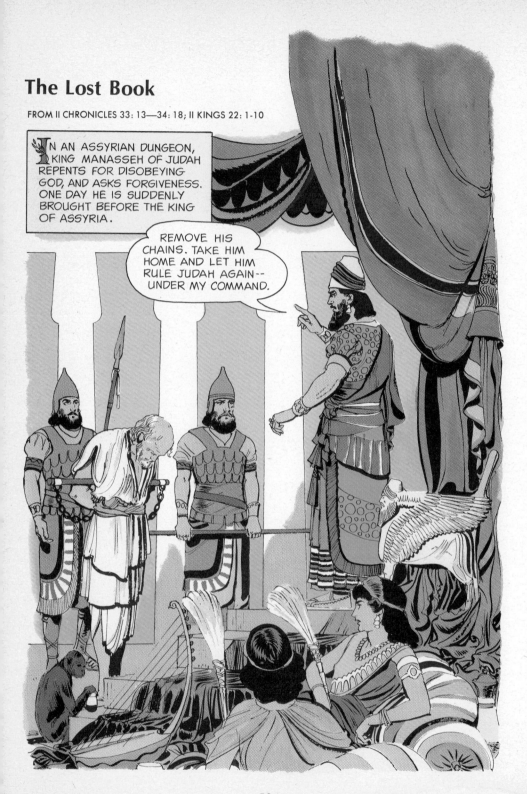

IN AN ASSYRIAN DUNGEON, KING MANASSEH OF JUDAH REPENTS FOR DISOBEYING GOD, AND ASKS FORGIVENESS. ONE DAY HE IS SUDDENLY BROUGHT BEFORE THE KING OF ASSYRIA.

REMOVE HIS CHAINS. TAKE HIM HOME AND LET HIM RULE JUDAH AGAIN-- UNDER MY COMMAND.

NO ONE KNOWS WHAT PROMPTED THE ASSYRIAN KING TO FREE MANASSEH--BUT WHEN HE RETURNS TO JERUSALEM HIS PEOPLE WELCOME HIM...

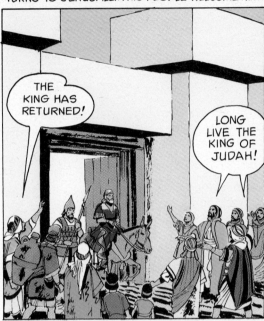

THE KING HAS RETURNED!

LONG LIVE THE KING OF JUDAH!

BUT THE PEOPLE ARE AMAZED AT HIS FIRST SPEECH...

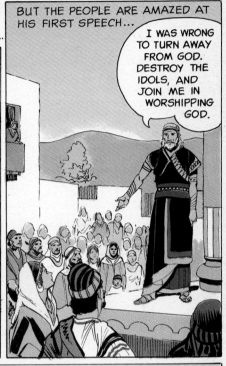

I WAS WRONG TO TURN AWAY FROM GOD. DESTROY THE IDOLS, AND JOIN ME IN WORSHIPPING GOD.

MANASSEH TRIES TO SAVE HIS NATION, BUT IT IS TOO LATE. MOST OF THE PEOPLE CONTINUE TO WORSHIP IDOLS. MANASSEH DIES, AND AFTER TWO YEARS, HIS EIGHT-YEAR-OLD GRANDSON, JOSIAH, COMES TO THE THRONE.

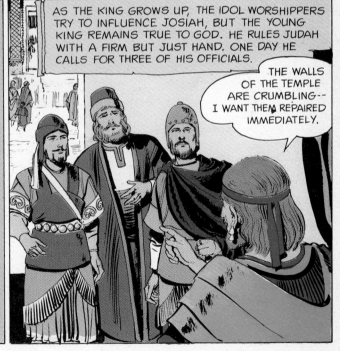

AS THE KING GROWS UP, THE IDOL WORSHIPPERS TRY TO INFLUENCE JOSIAH, BUT THE YOUNG KING REMAINS TRUE TO GOD. HE RULES JUDAH WITH A FIRM BUT JUST HAND. ONE DAY HE CALLS FOR THREE OF HIS OFFICIALS.

THE WALLS OF THE TEMPLE ARE CRUMBLING-- I WANT THEM REPAIRED IMMEDIATELY.

WORKMEN BEGIN AT ONCE. AFTER A WHILE THE HIGH PRIEST COMES TO CHECK THEIR PROGRESS...

STOP! WHAT'S THAT OBJECT BEHIND THOSE STONES?

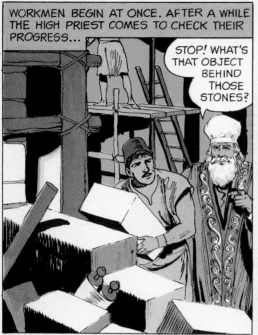

HE TAKES HIS DISCOVERY TO THE KING'S SCRIBE.

LOOK WHAT I HAVE FOUND! THE BOOK OF THE LAW!

IT HAS BEEN LOST FOR YEARS! LET ME READ IT!

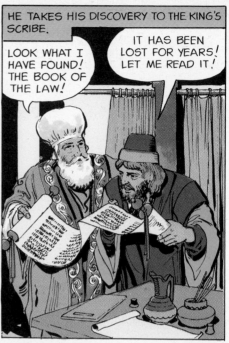

SLOWLY, CAREFULLY, THE SCRIBE READS THE ANCIENT SCROLL.

WHAT DOES IT SAY?

IT GIVES GOD'S LAWS--BUT IT ALSO TELLS WHAT WILL HAPPEN IF THE LAWS ARE NOT OBEYED. I MUST READ THIS TO THE KING.

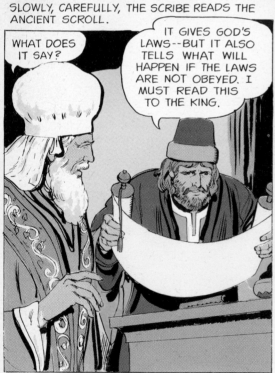

BUT I'M AFRAID THERE'S NOTHING HE--OR ANYBODY ELSE--CAN DO TO SAVE JUDAH!

A Prophetess Speaks

FROM II KINGS 22:11—24:20; II CHRONICLES 34:19—36:16.

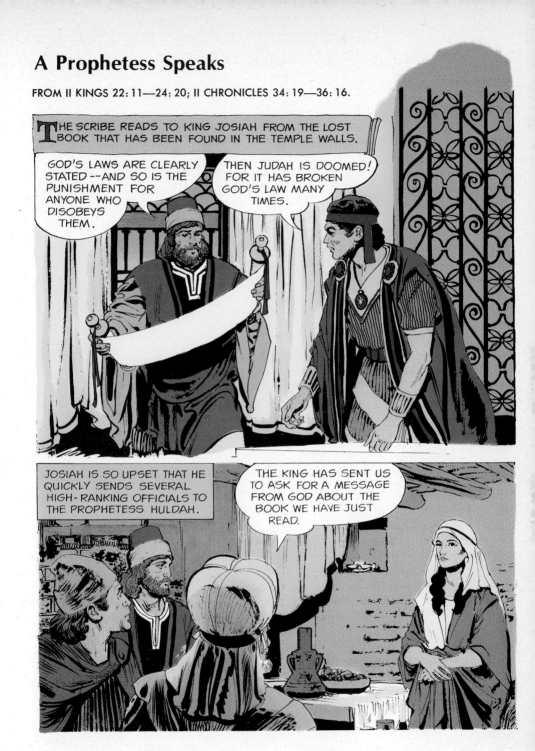

THE SCRIBE READS TO KING JOSIAH FROM THE LOST BOOK THAT HAS BEEN FOUND IN THE TEMPLE WALLS.

GOD'S LAWS ARE CLEARLY STATED--AND SO IS THE PUNISHMENT FOR ANYONE WHO DISOBEYS THEM.

THEN JUDAH IS DOOMED! FOR IT HAS BROKEN GOD'S LAW MANY TIMES.

JOSIAH IS SO UPSET THAT HE QUICKLY SENDS SEVERAL HIGH-RANKING OFFICIALS TO THE PROPHETESS HULDAH.

THE KING HAS SENT US TO ASK FOR A MESSAGE FROM GOD ABOUT THE BOOK WE HAVE JUST READ.

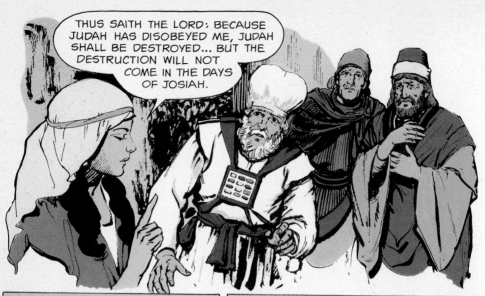

THUS SAITH THE LORD: BECAUSE JUDAH HAS DISOBEYED ME, JUDAH SHALL BE DESTROYED... BUT THE DESTRUCTION WILL NOT COME IN THE DAYS OF JOSIAH.

HOPING HE MAY YET WIN GOD'S FORGIVENESS FOR HIS NATION, JOSIAH CALLS A MEETING OF THE PEOPLE.

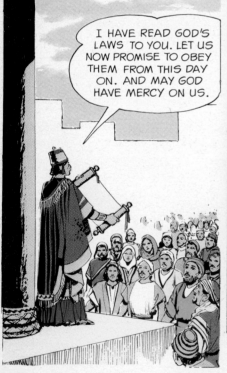

I HAVE READ GOD'S LAWS TO YOU. LET US NOW PROMISE TO OBEY THEM FROM THIS DAY ON. AND MAY GOD HAVE MERCY ON US.

AT JOSIAH'S COMMAND PAGAN WORSHIP IS WIPED OUT IN ALL THE LAND. OBJECTS USED IN IDOL WORSHIP ARE REMOVED FROM GOD'S TEMPLE IN JERUSALEM, TAKEN OUTSIDE THE CITY, AND BURNED.

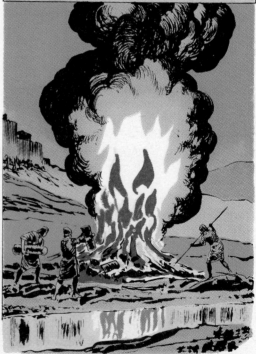

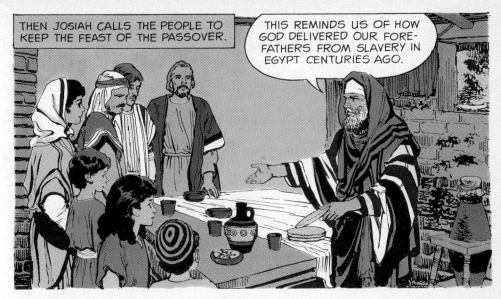

THEN JOSIAH CALLS THE PEOPLE TO KEEP THE FEAST OF THE PASSOVER.

THIS REMINDS US OF HOW GOD DELIVERED OUR FORE-FATHERS FROM SLAVERY IN EGYPT CENTURIES AGO.

WHILE JOSIAH LIVES, JUDAH OBEYS THE LAWS OF GOD. BUT AFTER HIS DEATH, ONE KING AFTER ANOTHER TURNS BACK TO THE WORSHIP OF IDOLS. LACKING GOD'S HELP, JUDAH COMES UNDER THE CONTROL OF A NEW WORLD POWER, BABYLONIA.

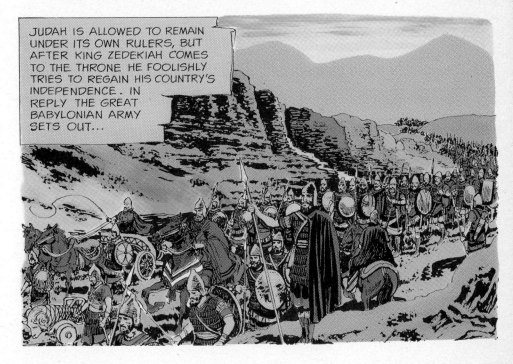

JUDAH IS ALLOWED TO REMAIN UNDER ITS OWN RULERS, BUT AFTER KING ZEDEKIAH COMES TO THE THRONE HE FOOLISHLY TRIES TO REGAIN HIS COUNTRY'S INDEPENDENCE. IN REPLY THE GREAT BABYLONIAN ARMY SETS OUT...

The Fall of Jerusalem

FROM II CHRONICLES 36: 17-20; II KINGS 25: 1-11

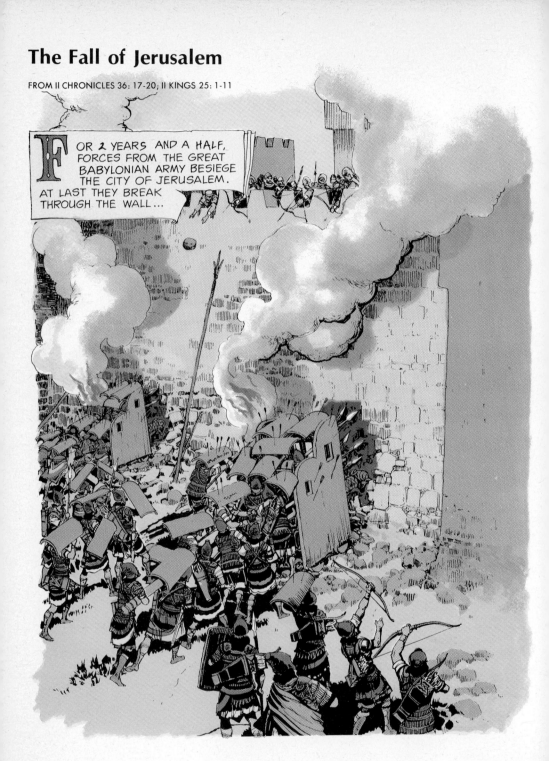

FOR 2 YEARS AND A HALF, FORCES FROM THE GREAT BABYLONIAN ARMY BESIEGE THE CITY OF JERUSALEM. AT LAST THEY BREAK THROUGH THE WALL...

THAT NIGHT KING ZEDEKIAH AND HIS ARMY TRY TO ESCAPE.

IF WE CAN MAKE IT TO THE HILL REGION EAST OF THE JORDAN, THEY'LL NEVER FIND US.

IT'S OUR ONLY CHANCE --IF THEY CAPTURE US...

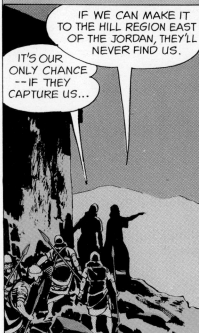

BUT THE BABYLONIANS PURSUE THEM, AND ZEDEKIAH IS CAPTURED BEFORE HE CAN REACH THE RIVER. HE IS BLINDED AND TAKEN TO BABYLON.

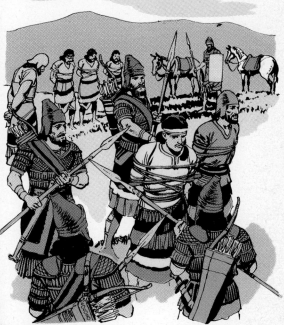

HUNGRY, WEARY, AND AFRAID, THE PEOPLE OF JERUSALEM ARE FORCED TO BEGIN THE LONG MARCH OF 900 MILES FROM JERUSALEM TO BABYLON--AS CAPTIVES.

GOD HAS FORSAKEN US.

NO. GOD WARNED US, BUT WE WOULD NOT LISTEN. IT IS WE WHO HAVE FORSAKEN GOD!

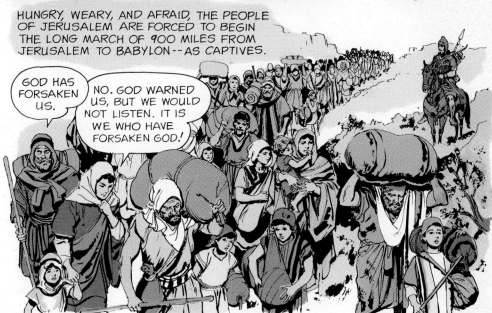

SILVER, GOLD, AND ALL OBJECTS OF VALUE ARE STRIPPED FROM THE TEMPLE AND PALACE BUILDINGS.

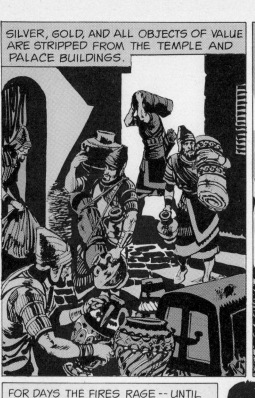

SET FIRE TO EVERY CORNER OF THE CITY-- LET NOTHING REMAIN THAT WILL GIVE ANYONE IDEAS ABOUT REBUILDING IT.

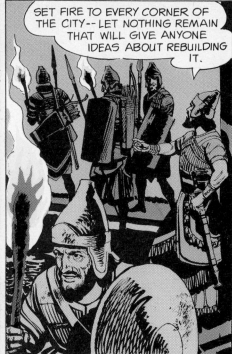

FOR DAYS THE FIRES RAGE -- UNTIL ALL THAT IS LEFT OF THE BEAUTIFUL CITY OF JERUSALEM IS A HEAP OF ASHES AND BLACKENED STONES...

BUT ON THE WAY TO BABYLON A FEW BRAVE CAPTIVES DREAM OF A DAY WHEN THEY MAY RETURN...

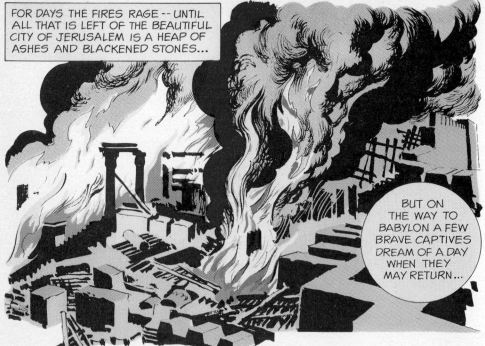

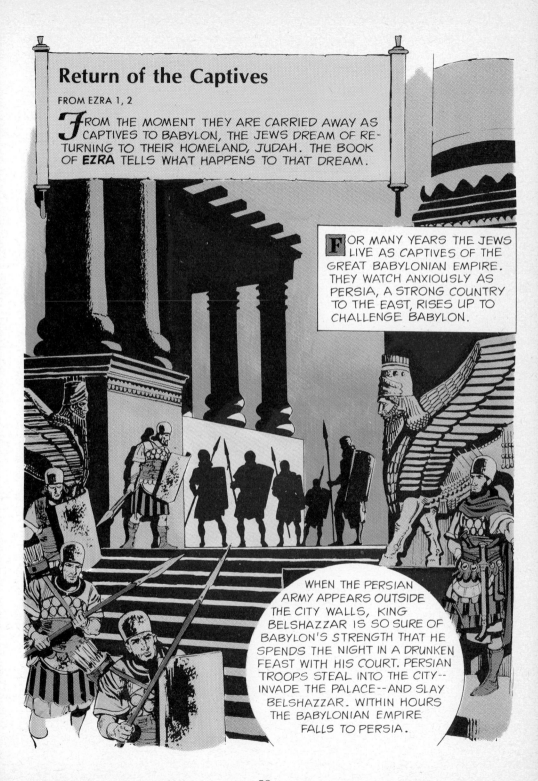

Return of the Captives

FROM EZRA 1, 2

FROM THE MOMENT THEY ARE CARRIED AWAY AS CAPTIVES TO BABYLON, THE JEWS DREAM OF RETURNING TO THEIR HOMELAND, JUDAH. THE BOOK OF **EZRA** TELLS WHAT HAPPENS TO THAT DREAM.

FOR MANY YEARS THE JEWS LIVE AS CAPTIVES OF THE GREAT BABYLONIAN EMPIRE. THEY WATCH ANXIOUSLY AS PERSIA, A STRONG COUNTRY TO THE EAST, RISES UP TO CHALLENGE BABYLON.

WHEN THE PERSIAN ARMY APPEARS OUTSIDE THE CITY WALLS, KING BELSHAZZAR IS SO SURE OF BABYLON'S STRENGTH THAT HE SPENDS THE NIGHT IN A DRUNKEN FEAST WITH HIS COURT. PERSIAN TROOPS STEAL INTO THE CITY-- INVADE THE PALACE--AND SLAY BELSHAZZAR. WITHIN HOURS THE BABYLONIAN EMPIRE FALLS TO PERSIA.

TWO WEEKS LATER KING CYRUS OF PERSIA RIDES TRIUMPHANTLY INTO THE CITY.

SO THAT'S OUR NEW RULER. I WONDER--DOES THIS MEAN GOOD OR EVIL FOR US JEWS?

I'VE HEARD THAT CYRUS IS A JUST MAN. WE'LL HAVE TO WAIT AND SEE.

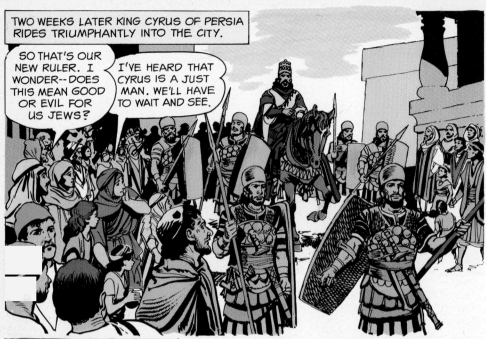

SOON AFTER CYRUS TAKES OVER THE BABYLONIAN EMPIRE, AN OFFICIAL ANNOUNCEMENT IS READ.

THESE ARE THE WORDS OF KING CYRUS: THE GOD OF ISRAEL COMMANDS THAT A HOUSE BE BUILT FOR HIM IN JERUSALEM. ANY OF HIS PEOPLE WHO WANT TO DO SO MAY RETURN. THOSE WHO DO NOT GO BACK SHOULD GIVE OF THEIR POSSESSIONS TO HELP THOSE WHO RETURN TO JUDAH.

GIFTS OF MONEY, HORSES, MULES, CAMELS, GOLD AND SILVER, FOOD AND CLOTHING POUR IN. AT LAST THE DAY COMES WHEN THE GREAT CARAVAN IS READY TO LEAVE.

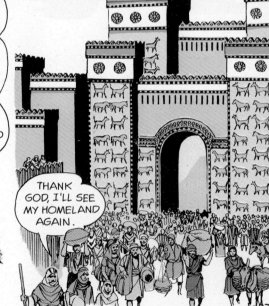

THANK GOD, I'LL SEE MY HOMELAND AGAIN.

ON THE LONG ROAD HOME, THEY FOLLOW MUCH THE SAME ROUTE THAT ABRAHAM, THE FATHER OF THE JEWISH NATION, TRAVELLED 1,500 YEARS BEFORE WHEN HE OBEYED GOD'S COMMAND TO LEAVE UR AND MAKE A NEW NATION IN PALESTINE.

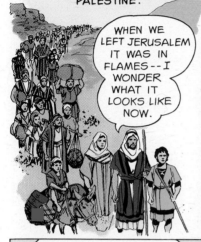

WHEN WE LEFT JERUSALEM IT WAS IN FLAMES -- I WONDER WHAT IT LOOKS LIKE NOW.

BUT NO MATTER HOW MUCH THEY PREPARE THEMSELVES FOR THE RUINED CITY, THEY ARE BROKENHEARTED WHEN THEY WALK THROUGH THE RUBBLE OF JERUSALEM.

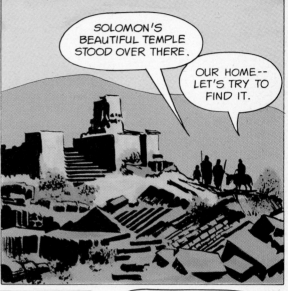

SOLOMON'S BEAUTIFUL TEMPLE STOOD OVER THERE.

OUR HOME-- LET'S TRY TO FIND IT.

HOW PROUD WE WERE WHEN WE BUILT IT-- WITH OUR OWN HANDS, TOO. NOW LOOK AT IT-- A HOME FOR WILD DOGS.

MAYBE WE SHOULD NOT HAVE COME BACK. MAYBE...

OUR FOREFATHERS BUILT MUCH OF THIS CITY. WE'LL REBUILD IT -- JERUSALEM WILL RISE AGAIN. YOU'LL SEE...

A City Rises Again

FROM EZRA 3—10

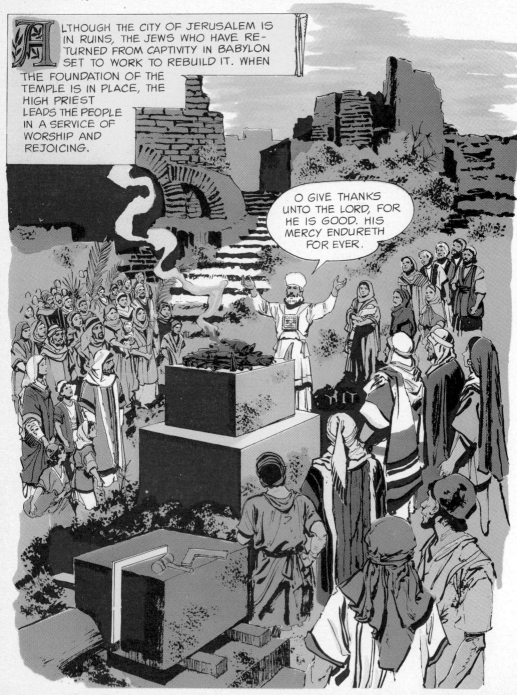

ALTHOUGH THE CITY OF JERUSALEM IS IN RUINS, THE JEWS WHO HAVE RETURNED FROM CAPTIVITY IN BABYLON SET TO WORK TO REBUILD IT. WHEN THE FOUNDATION OF THE TEMPLE IS IN PLACE, THE HIGH PRIEST LEADS THE PEOPLE IN A SERVICE OF WORSHIP AND REJOICING.

O GIVE THANKS UNTO THE LORD, FOR HE IS GOOD. HIS MERCY ENDURETH FOR EVER.

BUT THE SOUND OF REJOICING BRINGS TROUBLE. THE SAMARITANS WHO LIVE NEAR JERUSALEM COME WITH A REQUEST TO HELP BUILD THE TEMPLE.

WE'RE SORRY-- BUT YOU DO NOT WORSHIP AS WE DO, SO WE CANNOT LET YOU HELP US BUILD OUR TEMPLE TO GOD.

SO THEY "CAN'T" LET US HELP THEM BUILD THE TEMPLE! WELL, WE'LL MAKE THEM SORRY THEY EVER CAME BACK TO JERUSALEM TO BUILD ANYTHING.

WHAT DO YOU MEAN?

THE JEWS SOON LEARN WHAT THE SAMARITAN MEANT. ONE DAY WHILE THEY ARE AT WORK AN OFFICER OF KING CYRUS RIDES UP.

BY ORDER OF THE KING, THIS WORK IS TO STOP!

STOP? WHY? IT WAS KING CYRUS HIMSELF WHO TOLD US WE SHOULD RETURN TO JERUSALEM TO REBUILD THE TEMPLE!

UNHAPPILY, THE WORKMEN LAY DOWN THEIR TOOLS AND GO HOME.

FATHER, WHAT COULD HAVE HAPPENED? KING CYRUS SAID...

YES, BUT THE SAMARITANS WROTE HIM THAT WE WERE TRYING TO DESTROY HIS POWER HERE. THE KING IS INVESTIGATING THE CHARGES AND HAS ORDERED WORK ON THE TEMPLE STOPPED.

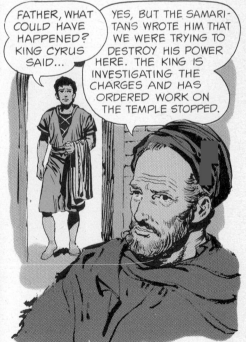

FORCED TO OBEY, THE JEWS TURN TO WORK ON THEIR HOMES AND GARDENS. SEVERAL YEARS PASS -- CYRUS DIES AND NEW KINGS COME TO THE THRONE IN PERSIA, BUT STILL THE TEMPLE IN JERUSALEM IS NOT COMPLETED. THEN, ONE DAY, THE JEWS ARE APPROACHED BY TWO PROPHETS OF GOD.

HAGGAI, ZECHARIAH! WHAT BRINGS YOU HERE?

WE HAVE NEWS.

A NEW KING, DARIUS, HAS COME TO THE THRONE. LET'S START WORK AGAIN ON THE TEMPLE -- MAYBE HE WON'T STOP US.

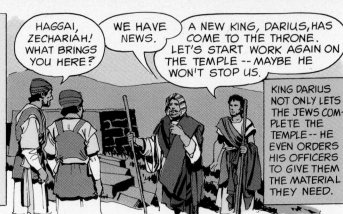

KING DARIUS NOT ONLY LETS THE JEWS COMPLETE THE TEMPLE -- HE EVEN ORDERS HIS OFFICERS TO GIVE THEM THE MATERIAL THEY NEED.

SO -- AT LAST -- THE NEW TEMPLE OF GOD IS FINISHED WITH THANKFUL HEARTS THE PEOPLE OFFER THEIR SACRIFICES AND PRAYERS TO GOD.

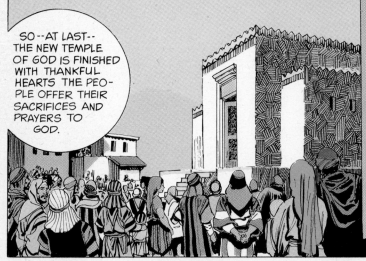

SOME YEARS LATER, EZRA, A PRIEST, GAINS PERMISSION FROM THE PERSIAN KING TO GO TO JERUSALEM TO TEACH THE PEOPLE THE LAWS OF GOD. HE TAKES A GROUP OF JEWS WITH HIM. UNDER EZRA JERUSALEM GROWS IN SIZE AND SPIRITUAL STRENGTH, BUT IS STILL WITHOUT WALLS AND SURROUNDED BY HOSTILE NEIGHBOURS.

ONE NIGHT, WHILE THE CITY SLEEPS, A STRANGER AND HIS GUARDS RIDE TOWARD JERUSALEM ...

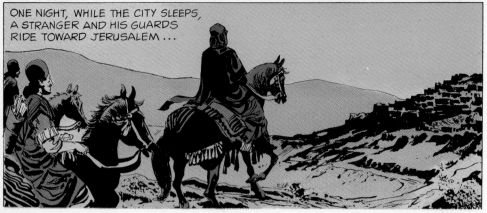

Two Lines of Defence

FROM NEHEMIAH

THE BOOK OF **NEHEMIAH** CONTINUES THE STORY OF THE JEWS' STRUGGLE TO REBUILD JERUSALEM.

AT NIGHT, SO THAT NO ONE WILL SEE HIM, A STRANGER TO JERUSALEM RIDES AROUND THE CITY AND EXAMINES THE WALLS.

THIS CITY COULD BE WIPED OUT IN ONE QUICK ATTACK.

YOU'RE RIGHT, NEHEMIAH. BUT IT MUST HAVE BEEN A GREAT FORTRESS AT ONE TIME. THESE WALLS ARE AS THICK AS ANY WE HAVE IN PERSIA.

THE NEXT DAY NEHEMIAH CALLS ON THE PRIESTS AND RULERS OF THE CITY.

I HAVE EXAMINED THE WALLS OF JERUSALEM. THEY ARE JUST HEAPS OF BROKEN STONE. THE CITY IS DEFENCELESS.

YOU ARE RIGHT, BUT WHY--

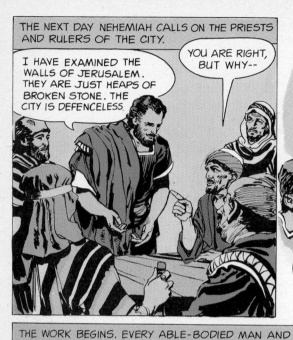

WHY HAVE I COME? BECAUSE I, TOO, AM A JEW. AND WHILE I WAS SERVING THE KING OF PERSIA AS HIS CUPBEARER, I LEARNED THAT JERUSALEM WAS WITHOUT ANY DEFENCE. I PRAYED TO GOD-- AND THE KING GAVE ME HIS PERMISSION TO COME HERE AND BUILD UP THE WALLS. ARE YOU WITH ME?

WE ARE-- AND WE'LL START AT ONCE.

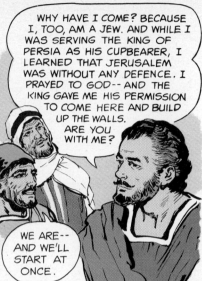

THE WORK BEGINS. EVERY ABLE-BODIED MAN AND BOY DOES HIS PART. THE WOMEN HELP... AND SLOWLY THE WALLS BEGIN TO RISE.

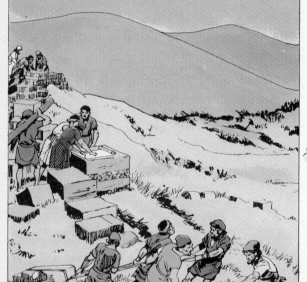

BUT SOME OF THE NEIGHBOURING COUNTRIES DO NOT WANT TO SEE JERUSALEM PROTECTED.

IF THOSE WALLS ARE FINISHED, THE CITY WILL BE TOO STRONG TO ATTACK. WE MUST STOP IT **NOW**.

DOWN WITH THE WALLS!

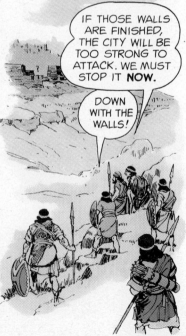

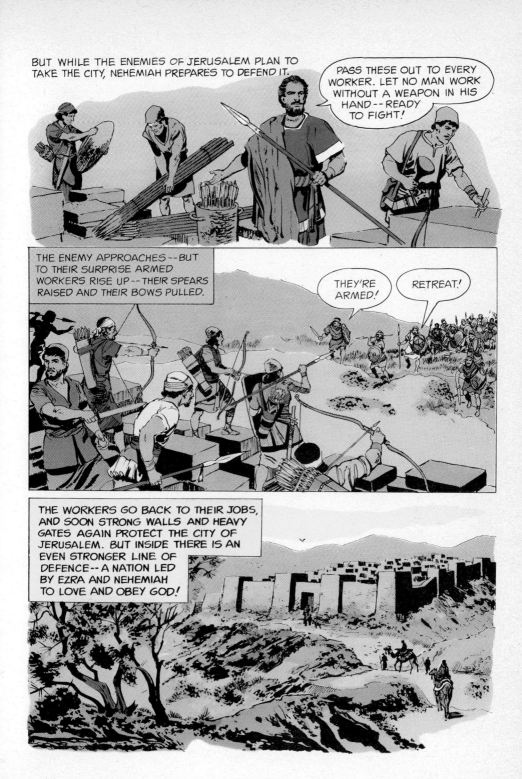

BUT WHILE THE ENEMIES OF JERUSALEM PLAN TO TAKE THE CITY, NEHEMIAH PREPARES TO DEFEND IT.

PASS THESE OUT TO EVERY WORKER. LET NO MAN WORK WITHOUT A WEAPON IN HIS HAND -- READY TO FIGHT!

THE ENEMY APPROACHES -- BUT TO THEIR SURPRISE ARMED WORKERS RISE UP -- THEIR SPEARS RAISED AND THEIR BOWS PULLED.

THEY'RE ARMED!

RETREAT!

THE WORKERS GO BACK TO THEIR JOBS, AND SOON STRONG WALLS AND HEAVY GATES AGAIN PROTECT THE CITY OF JERUSALEM. BUT INSIDE THERE IS AN EVEN STRONGER LINE OF DEFENCE -- A NATION LED BY EZRA AND NEHEMIAH TO LOVE AND OBEY GOD!

Search for a Queen

FROM ESTHER 1:1—2:11

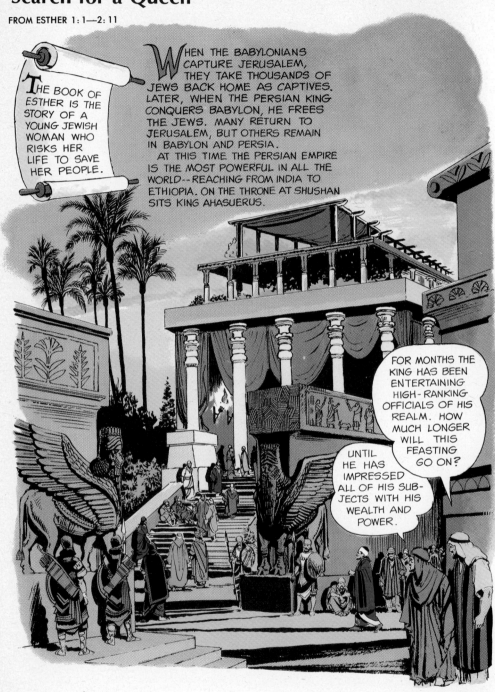

THE BOOK OF ESTHER IS THE STORY OF A YOUNG JEWISH WOMAN WHO RISKS HER LIFE TO SAVE HER PEOPLE.

WHEN THE BABYLONIANS CAPTURE JERUSALEM, THEY TAKE THOUSANDS OF JEWS BACK HOME AS CAPTIVES. LATER, WHEN THE PERSIAN KING CONQUERS BABYLON, HE FREES THE JEWS. MANY RETURN TO JERUSALEM, BUT OTHERS REMAIN IN BABYLON AND PERSIA.

AT THIS TIME THE PERSIAN EMPIRE IS THE MOST POWERFUL IN ALL THE WORLD-- REACHING FROM INDIA TO ETHIOPIA. ON THE THRONE AT SHUSHAN SITS KING AHASUERUS.

FOR MONTHS THE KING HAS BEEN ENTERTAINING HIGH-RANKING OFFICIALS OF HIS REALM. HOW MUCH LONGER WILL THIS FEASTING GO ON?

UNTIL HE HAS IMPRESSED ALL OF HIS SUBJECTS WITH HIS WEALTH AND POWER.

Plot Against the King

FROM ESTHER 2:11—3:6

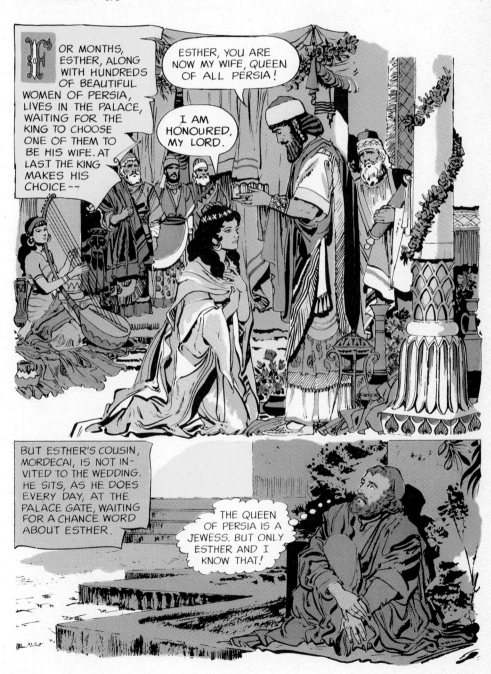

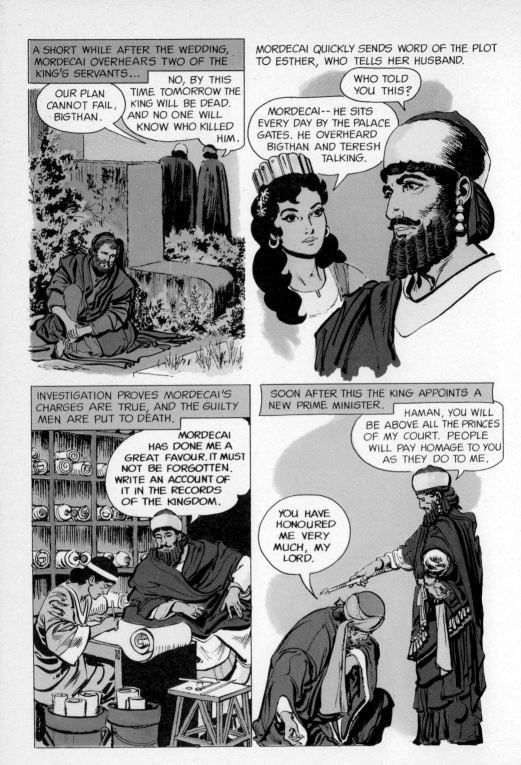

A SHORT WHILE AFTER THE WEDDING, MORDECAI OVERHEARS TWO OF THE KING'S SERVANTS...

OUR PLAN CANNOT FAIL, BIGTHAN.

NO, BY THIS TIME TOMORROW THE KING WILL BE DEAD. AND NO ONE WILL KNOW WHO KILLED HIM.

MORDECAI QUICKLY SENDS WORD OF THE PLOT TO ESTHER, WHO TELLS HER HUSBAND.

WHO TOLD YOU THIS?

MORDECAI-- HE SITS EVERY DAY BY THE PALACE GATES. HE OVERHEARD BIGTHAN AND TERESH TALKING.

INVESTIGATION PROVES MORDECAI'S CHARGES ARE TRUE, AND THE GUILTY MEN ARE PUT TO DEATH.

MORDECAI HAS DONE ME A GREAT FAVOUR. IT MUST NOT BE FORGOTTEN. WRITE AN ACCOUNT OF IT IN THE RECORDS OF THE KINGDOM.

SOON AFTER THIS THE KING APPOINTS A NEW PRIME MINISTER.

HAMAN, YOU WILL BE ABOVE ALL THE PRINCES OF MY COURT. PEOPLE WILL PAY HOMAGE TO YOU AS THEY DO TO ME.

YOU HAVE HONOURED ME VERY MUCH, MY LORD.

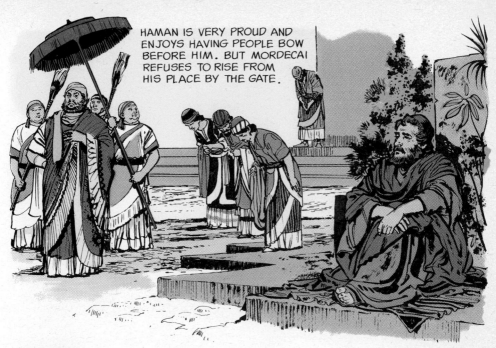

HAMAN IS VERY PROUD AND ENJOYS HAVING PEOPLE BOW BEFORE HIM. BUT MORDECAI REFUSES TO RISE FROM HIS PLACE BY THE GATE.

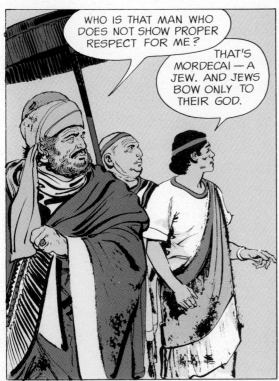

WHO IS THAT MAN WHO DOES NOT SHOW PROPER RESPECT FOR ME?

THAT'S MORDECAI — A JEW. AND JEWS BOW ONLY TO THEIR GOD.

MORDECAI WILL PAY FOR THIS -- AND SO WILL EVERY JEW IN PERSIA!

Revenge!

FROM ESTHER 3: 8—4: 8

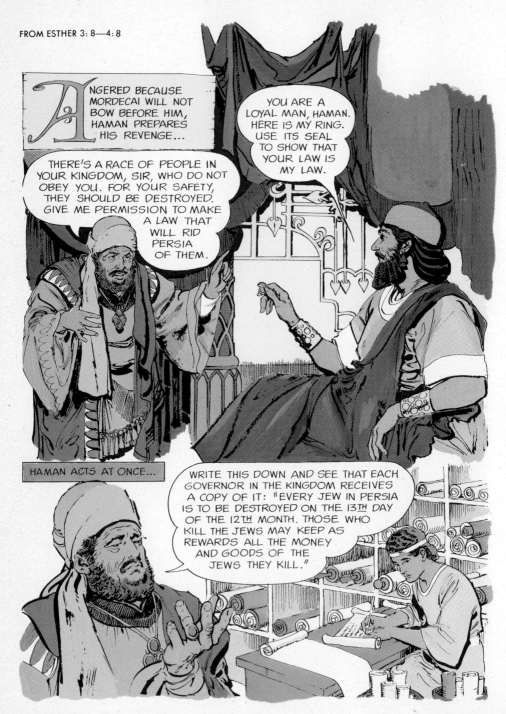

ANGERED BECAUSE MORDECAI WILL NOT BOW BEFORE HIM, HAMAN PREPARES HIS REVENGE...

THERE'S A RACE OF PEOPLE IN YOUR KINGDOM, SIR, WHO DO NOT OBEY YOU. FOR YOUR SAFETY, THEY SHOULD BE DESTROYED. GIVE ME PERMISSION TO MAKE A LAW THAT WILL RID PERSIA OF THEM.

YOU ARE A LOYAL MAN, HAMAN. HERE IS MY RING. USE ITS SEAL TO SHOW THAT YOUR LAW IS MY LAW.

HAMAN ACTS AT ONCE...

WRITE THIS DOWN AND SEE THAT EACH GOVERNOR IN THE KINGDOM RECEIVES A COPY OF IT: "EVERY JEW IN PERSIA IS TO BE DESTROYED ON THE 13TH DAY OF THE 12TH MONTH. THOSE WHO KILL THE JEWS MAY KEEP AS REWARDS ALL THE MONEY AND GOODS OF THE JEWS THEY KILL."

THE ORDERS ARE WRITTEN AND DELIVERED. THROUGHOUT THE KINGDOM JEWISH FAMILIES ARE TERRIFIED...

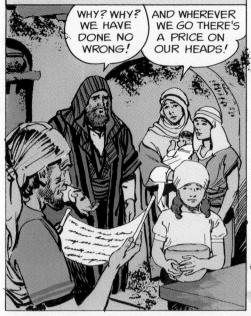

WHY? WHY? WE HAVE DONE NO WRONG!

AND WHEREVER WE GO THERE'S A PRICE ON OUR HEADS!

WHEN MORDECAI HEARS THE ORDERS HE DRESSES IN CLOTHES OF MOURNING AND POURS ASHES OVER HIS HEAD TO SHOW HIS GRIEF...

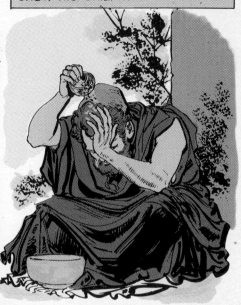

FROM HER PALACE WINDOW ESTHER SEES THAT SOMETHING IS WRONG.

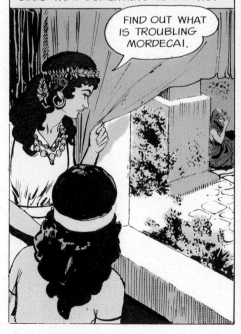

FIND OUT WHAT IS TROUBLING MORDECAI.

THE QUEEN ASKS WHY I MOURN? DOESN'T SHE KNOW THAT HAMAN'S ORDER MEANS DEATH TO EVERY JEW IN PERSIA? SHOW THIS TO HER -- TELL HER SHE MUST GO TO THE KING AND ASK HIM TO SPARE THE JEWS.

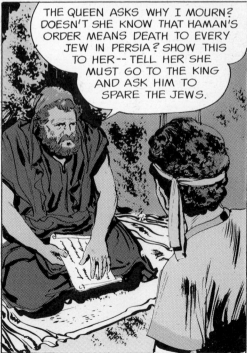

A Queen Risks Her Life

FROM ESTHER 5:1—6:10

QUEEN ESTHER BREAKS A LAW BY APPEARING UNINVITED BEFORE THE KING--AN ACT PUNISHABLE BY DEATH. BUT THE LIVES OF HER PEOPLE, THE JEWS, ARE IN DANGER, AND SHE IS THE ONLY ONE WHO MAY BE ABLE TO SAVE THEM.

ESTHER! WHAT DOES SHE WANT THAT SHE WOULD RISK HER LIFE TO GET?

SURPRISED AS HE IS BY HER SUDDEN APPEARANCE, THE KING IS PLEASED AT THE SIGHT OF HIS BEAUTIFUL QUEEN. HE HOLDS OUT HIS SCEPTRE TO SHOW THAT SHE IS FORGIVEN, AND ASKS WHAT SHE WANTS.

I ASK THAT YOU AND HAMAN COME TO A DINNER THAT I SHALL PREPARE FOR YOU.

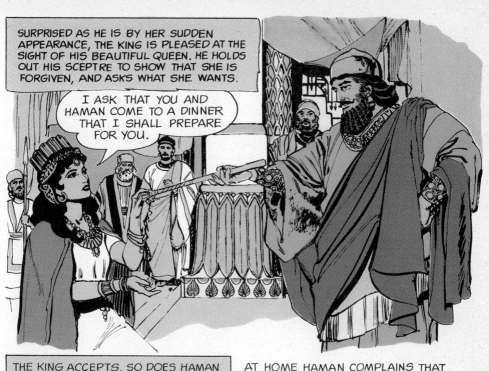

THE KING ACCEPTS. SO DOES HAMAN -- WHO IS OVERJOYED UNTIL HE LEAVES THE PALACE.

THAT STUBBORN JEW -- HE STILL WON'T BOW BEFORE ME! WELL, HE'LL SOON BE DEAD WITH ALL THE OTHER JEWS.

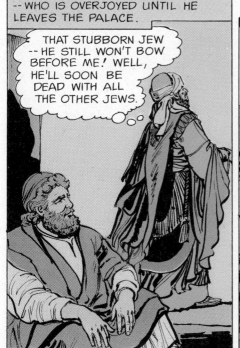

AT HOME HAMAN COMPLAINS THAT MORDECAI HAS INSULTED HIM.

DON'T STAND FOR IT, HAMAN. BUILD A GALLOWS AND TELL THE KING YOU WANT MORDECAI HANGED. THEN YOU CAN ENJOY YOUR DINNER WITH THE QUEEN.

I'LL DO IT! I'LL HAVE THE GALLOWS MADE AND GO TO SEE THE KING EARLY IN THE MORNING.

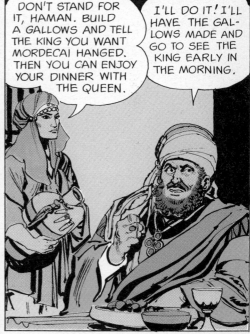

BUT THAT NIGHT THE KING CANNOT SLEEP. HE CALLS FOR A SCRIBE TO READ TO HIM FROM THE RECORDS OF THE KINGDOM. WHEN THE READING REACHES THE STORY OF MORDECAI, THE KING INTERRUPTS.

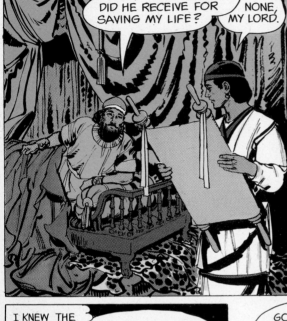

STOP! WHAT REWARD DID HE RECEIVE FOR SAVING MY LIFE?

NONE, MY LORD.

AT THAT MOMENT HAMAN ENTERS THE COURT AND IS BROUGHT BEFORE THE KING.

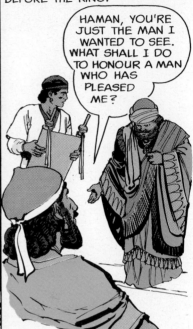

HAMAN, YOU'RE JUST THE MAN I WANTED TO SEE. WHAT SHALL I DO TO HONOUR A MAN WHO HAS PLEASED ME?

I KNEW THE KING WOULD RECOGNIZE MY SERVICES.

LET HIM WEAR ONE OF YOUR ROBES -- AND RIDE YOUR HORSE. THEN HAVE ONE OF YOUR NOBLES LEAD HIM THROUGH THE CITY TELLING EVERYONE THAT THIS IS THE WAY THE KING HONOURS THOSE WHO PLEASE HIM.

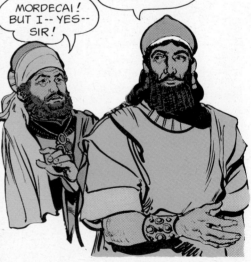

GOOD! GET THE ROBE AND THE HORSE AND DO EXACTLY AS YOU HAVE SUGGESTED -- FOR MORDECAI.

MORDECAI! BUT I -- YES -- SIR!

The Unchangeable Law

FROM ESTHER 6: 11—10

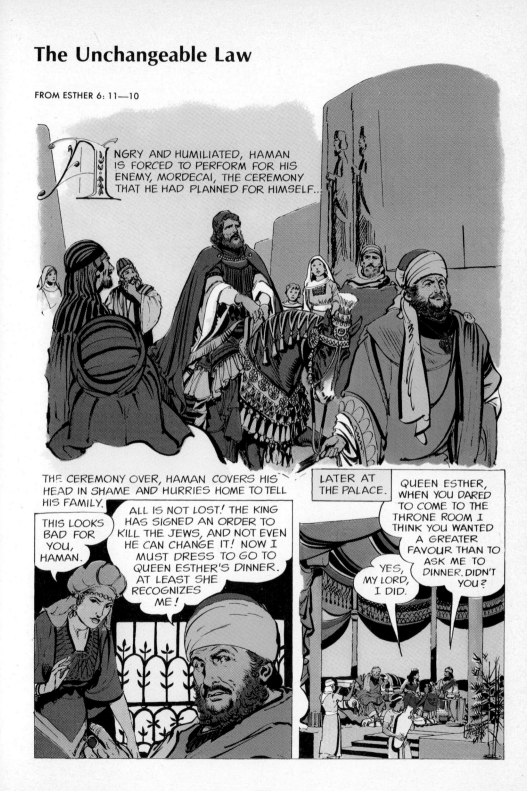

NGRY AND HUMILIATED, HAMAN IS FORCED TO PERFORM FOR HIS ENEMY, MORDECAI, THE CEREMONY THAT HE HAD PLANNED FOR HIMSELF...

THE CEREMONY OVER, HAMAN COVERS HIS HEAD IN SHAME AND HURRIES HOME TO TELL HIS FAMILY.

THIS LOOKS BAD FOR YOU, HAMAN.

ALL IS NOT LOST! THE KING HAS SIGNED AN ORDER TO KILL THE JEWS, AND NOT EVEN HE CAN CHANGE IT! NOW I MUST DRESS TO GO TO QUEEN ESTHER'S DINNER. AT LEAST SHE RECOGNIZES ME!

LATER AT THE PALACE.

QUEEN ESTHER, WHEN YOU DARED TO COME TO THE THRONE ROOM I THINK YOU WANTED A GREATER FAVOUR THAN TO ASK ME TO DINNER. DIDN'T YOU?

YES, MY LORD, I DID.

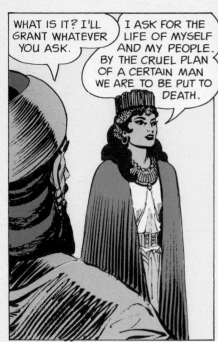

WHAT IS IT? I'LL GRANT WHATEVER YOU ASK.

I ASK FOR THE LIFE OF MYSELF AND MY PEOPLE. BY THE CRUEL PLAN OF A CERTAIN MAN WE ARE TO BE PUT TO DEATH.

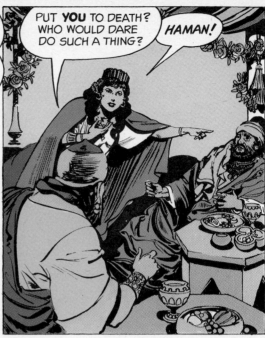

PUT **YOU** TO DEATH? WHO WOULD DARE DO SUCH A THING?

HAMAN!

NOW, FOR THE FIRST TIME THE KING KNOWS THAT HIS WIFE IS JEWISH, AND THAT HAMAN TRICKED HIM INTO SIGNING HER DEATH WARRANT. IN ANGER THE KING LEAVES THE ROOM.

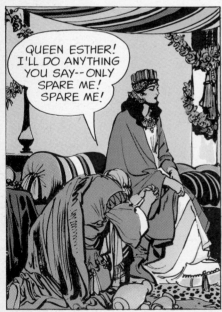

QUEEN ESTHER! I'LL DO ANYTHING YOU SAY-- ONLY SPARE ME! SPARE ME!

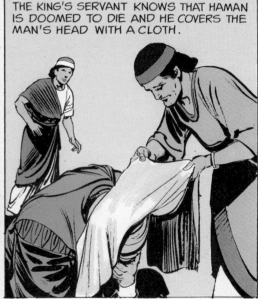

THE KING'S SERVANT KNOWS THAT HAMAN IS DOOMED TO DIE AND HE COVERS THE MAN'S HEAD WITH A CLOTH.

HAMAN BUILT A GALLOWS ON WHICH HE WANTED TO HANG MORDECAI.

AND ON THAT GALLOWS HAMAN SHALL HANG. TAKE HIM AWAY.

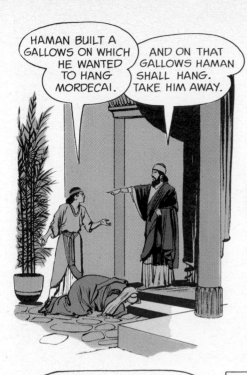

YOU SHALL HAVE HAMAN'S WEALTH FOR THE SUFFERING HE HAS CAUSED YOU.

MY COUSIN, MORDECAI, HAS SUFFERED, TOO.

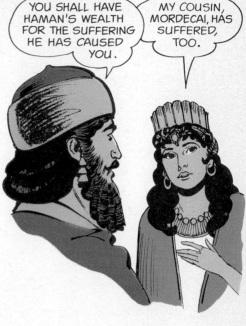

MORDECAI IS YOUR COUSIN? I'LL PUT HIM IN HAMAN'S PLACE --SECOND IN POWER IN ALL OF MY KINGDOM. WITH HAMAN OUT OF THE WAY, NO ONE WILL DARE TO HARM EITHER OF YOU.

A FEW DAYS LATER ESTHER TAKES THE SECOND STEP IN HER CAMPAIGN.

IF I HAVE PLEASED YOU, I BEG YOU TO TAKE BACK THE ORDER HAMAN SENT TO KILL ALL THE JEWS.

I WISH I COULD. BUT ACCORDING TO PERSIAN LAW, NO MAN -- NOT EVEN I-- CAN CANCEL AN ORDER THAT HAS BEEN SIGNED WITH MY SEAL.

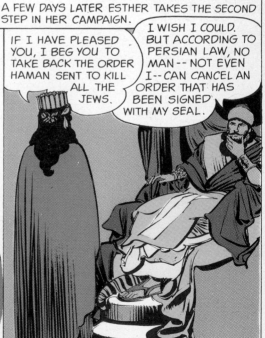

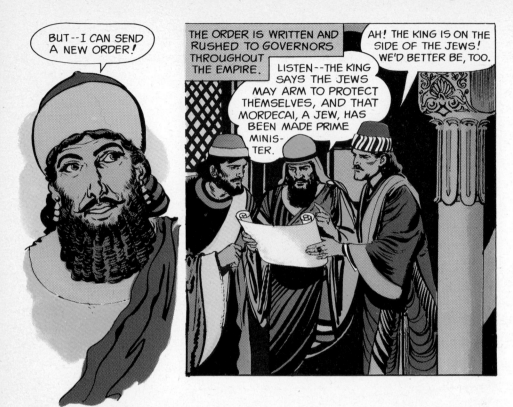

BUT--I CAN SEND A NEW ORDER!

THE ORDER IS WRITTEN AND RUSHED TO GOVERNORS THROUGHOUT THE EMPIRE.

LISTEN--THE KING SAYS THE JEWS MAY ARM TO PROTECT THEMSELVES, AND THAT MORDECAI, A JEW, HAS BEEN MADE PRIME MINISTER.

AH! THE KING IS ON THE SIDE OF THE JEWS! WE'D BETTER BE, TOO.

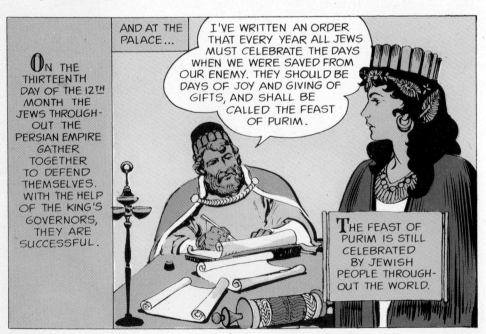

ON THE THIRTEENTH DAY OF THE 12TH MONTH THE JEWS THROUGHOUT THE PERSIAN EMPIRE GATHER TOGETHER TO DEFEND THEMSELVES. WITH THE HELP OF THE KING'S GOVERNORS, THEY ARE SUCCESSFUL.

AND AT THE PALACE...

I'VE WRITTEN AN ORDER THAT EVERY YEAR ALL JEWS MUST CELEBRATE THE DAYS WHEN WE WERE SAVED FROM OUR ENEMY. THEY SHOULD BE DAYS OF JOY AND GIVING OF GIFTS, AND SHALL BE CALLED THE FEAST OF PURIM.

THE FEAST OF PURIM IS STILL CELEBRATED BY JEWISH PEOPLE THROUGHOUT THE WORLD.

A Man with a Message

FROM THE BOOK OF ISAIAH

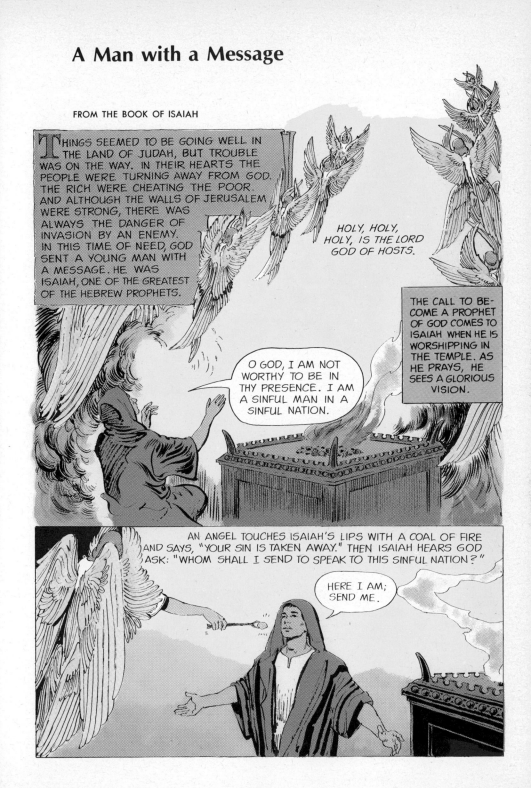

THINGS SEEMED TO BE GOING WELL IN THE LAND OF JUDAH, BUT TROUBLE WAS ON THE WAY. IN THEIR HEARTS THE PEOPLE WERE TURNING AWAY FROM GOD. THE RICH WERE CHEATING THE POOR. AND ALTHOUGH THE WALLS OF JERUSALEM WERE STRONG, THERE WAS ALWAYS THE DANGER OF INVASION BY AN ENEMY. IN THIS TIME OF NEED, GOD SENT A YOUNG MAN WITH A MESSAGE. HE WAS ISAIAH, ONE OF THE GREATEST OF THE HEBREW PROPHETS.

HOLY, HOLY, HOLY, IS THE LORD GOD OF HOSTS.

THE CALL TO BECOME A PROPHET OF GOD COMES TO ISAIAH WHEN HE IS WORSHIPPING IN THE TEMPLE. AS HE PRAYS, HE SEES A GLORIOUS VISION.

O GOD, I AM NOT WORTHY TO BE IN THY PRESENCE. I AM A SINFUL MAN IN A SINFUL NATION.

AN ANGEL TOUCHES ISAIAH'S LIPS WITH A COAL OF FIRE AND SAYS, "YOUR SIN IS TAKEN AWAY." THEN ISAIAH HEARS GOD ASK: "WHOM SHALL I SEND TO SPEAK TO THIS SINFUL NATION?"

HERE I AM; SEND ME.

FOR MORE THAN FIFTY YEARS ISAIAH PLEADS
WITH HIS PEOPLE TO DESTROY THEIR IDOLS
AND WORSHIP GOD. BUT ONLY A FEW LISTEN.
HE WARNS THE KINGS OF WHAT WILL HAPPEN
IF THEY DISOBEY GOD, BUT THE KINGS IGNORE
THE WARNINGS. AT LAST ISAIAH PROPHESIES
DESTRUCTION...

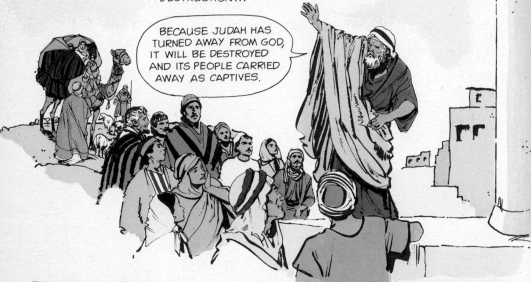

BECAUSE JUDAH HAS
TURNED AWAY FROM GOD,
IT WILL BE DESTROYED
AND ITS PEOPLE CARRIED
AWAY AS CAPTIVES.

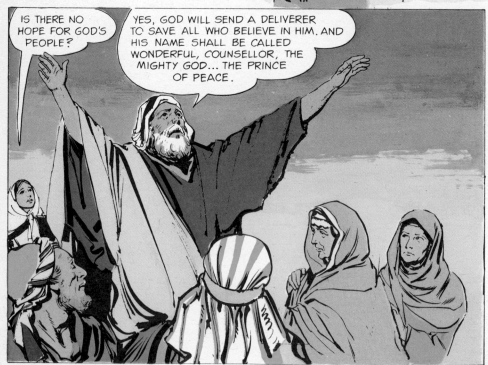

IS THERE NO
HOPE FOR GOD'S
PEOPLE?

YES, GOD WILL SEND A DELIVERER
TO SAVE ALL WHO BELIEVE IN HIM. AND
HIS NAME SHALL BE CALLED
WONDERFUL, COUNSELLOR, THE
MIGHTY GOD... THE PRINCE
OF PEACE.

A Call from God

FROM JEREMIAH 1; II KINGS 22:1—23:29

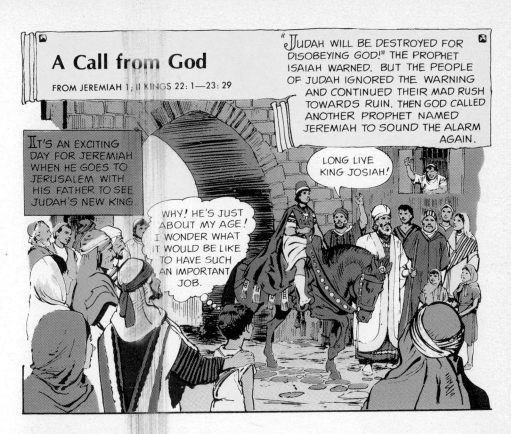

"JUDAH WILL BE DESTROYED FOR DISOBEYING GOD!" THE PROPHET ISAIAH WARNED. BUT THE PEOPLE OF JUDAH IGNORED THE WARNING AND CONTINUED THEIR MAD RUSH TOWARDS RUIN. THEN GOD CALLED ANOTHER PROPHET NAMED JEREMIAH TO SOUND THE ALARM AGAIN.

IT'S AN EXCITING DAY FOR JEREMIAH WHEN HE GOES TO JERUSALEM WITH HIS FATHER TO SEE JUDAH'S NEW KING.

LONG LIVE KING JOSIAH!

WHY! HE'S JUST ABOUT MY AGE! I WONDER WHAT IT WOULD BE LIKE TO HAVE SUCH AN IMPORTANT JOB.

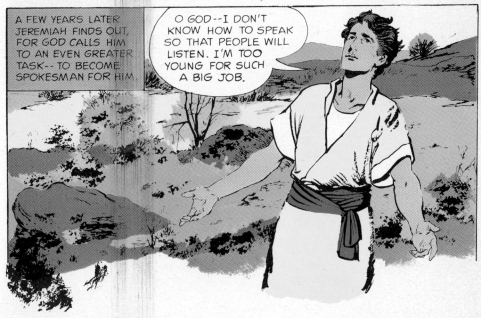

A FEW YEARS LATER JEREMIAH FINDS OUT, FOR GOD CALLS HIM TO AN EVEN GREATER TASK-- TO BECOME SPOKESMAN FOR HIM.

O GOD--I DON'T KNOW HOW TO SPEAK SO THAT PEOPLE WILL LISTEN. I'M TOO YOUNG FOR SUCH A BIG JOB.

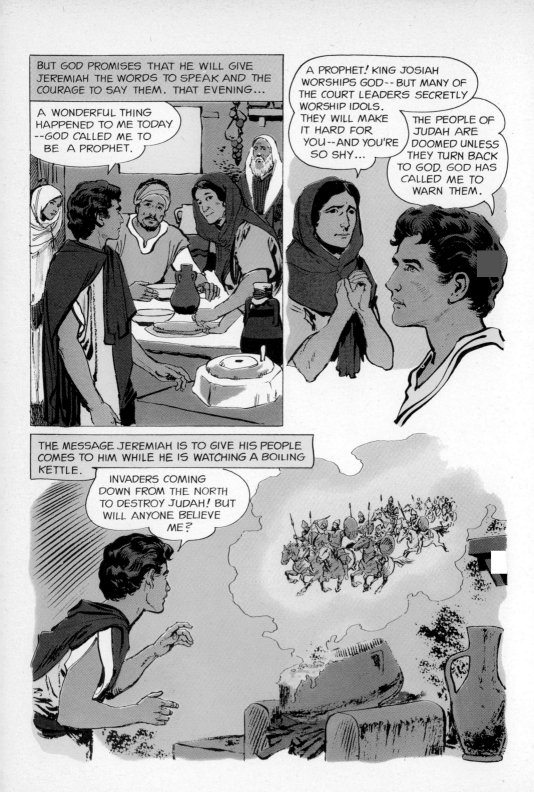

HE SOON FINDS OUT--WHEN HE TELLS THE PRIESTS IN HIS OWN TOWN THAT JUDAH WILL BE DESTROYED BECAUSE THE PEOPLE HAVE TURNED FROM GOD TO WORSHIP IDOLS.

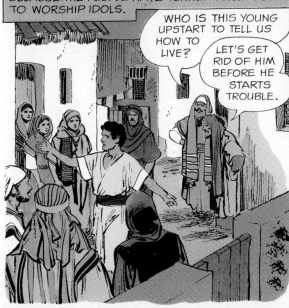

WHO IS THIS YOUNG UPSTART TO TELL US HOW TO LIVE?

LET'S GET RID OF HIM BEFORE HE STARTS TROUBLE.

SO, TO SAVE HIS LIFE, JEREMIAH IS FORCED TO LEAVE HIS HOME TOWN AND GO TO JERUSALEM.

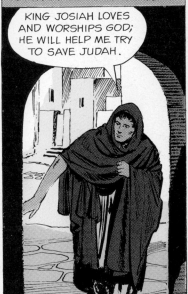

KING JOSIAH LOVES AND WORSHIPS GOD; HE WILL HELP ME TRY TO SAVE JUDAH.

FOR SEVERAL YEARS JEREMIAH AND THE KING WORK TOGETHER TO DESTROY IDOL WORSHIP. THEN, ONE DAY, JEREMIAH HEARS SOME FRIGHTENING NEWS.

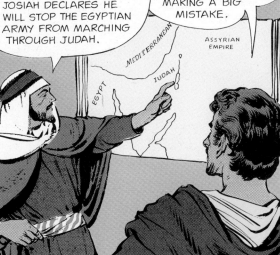

THE ASSYRIAN EMPIRE IS CRACKING UP. EGYPT IS MARCHING NORTH TO GRAB WHAT'S LEFT. KING JOSIAH DECLARES HE WILL STOP THE EGYPTIAN ARMY FROM MARCHING THROUGH JUDAH.

STOP EGYPT? WHY, IT'S ONE OF THE STRONGEST COUNTRIES IN THE WORLD! THE KING IS MAKING A BIG MISTAKE.

MEDITERRANEAN

EGYPT

JUDAH

ASSYRIAN EMPIRE

BUT KING JOSIAH LEADS HIS SOLDIERS OUT OF THE GATES OF JERUSALEM —AND INTO THE PATH OF THE ONCOMING EGYPTIAN ARMY.

Surrender

FROM JEREMIAH 18—36

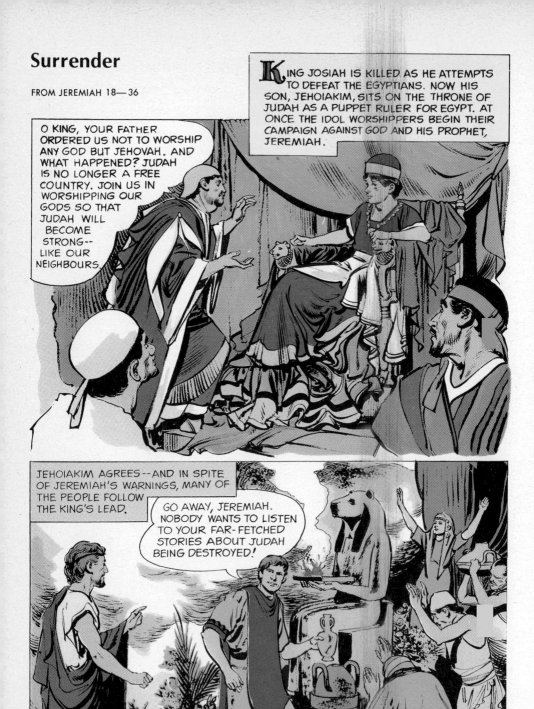

KING JOSIAH IS KILLED AS HE ATTEMPTS TO DEFEAT THE EGYPTIANS. NOW HIS SON, JEHOIAKIM, SITS ON THE THRONE OF JUDAH AS A PUPPET RULER FOR EGYPT. AT ONCE THE IDOL WORSHIPPERS BEGIN THEIR CAMPAIGN AGAINST GOD AND HIS PROPHET, JEREMIAH.

O KING, YOUR FATHER ORDERED US NOT TO WORSHIP ANY GOD BUT JEHOVAH. AND WHAT HAPPENED? JUDAH IS NO LONGER A FREE COUNTRY. JOIN US IN WORSHIPPING OUR GODS SO THAT JUDAH WILL BECOME STRONG-- LIKE OUR NEIGHBOURS.

JEHOIAKIM AGREES--AND IN SPITE OF JEREMIAH'S WARNINGS, MANY OF THE PEOPLE FOLLOW THE KING'S LEAD.

GO AWAY, JEREMIAH. NOBODY WANTS TO LISTEN TO YOUR FAR-FETCHED STORIES ABOUT JUDAH BEING DESTROYED!

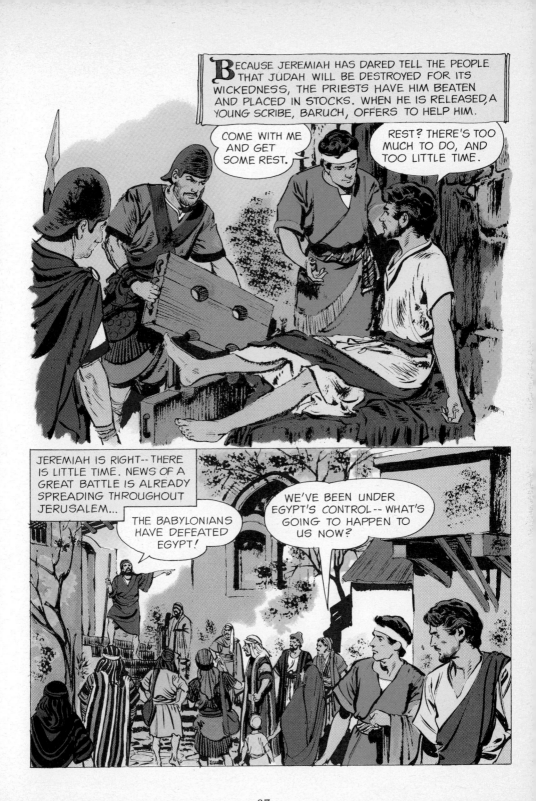

JUDAH DOESN'T HAVE LONG TO WAIT FOR ITS ANSWER. BABYLON ATTACKS JERUSALEM, AND KING JEHOIAKIM IS FORCED TO SURRENDER.

YOU MAY REMAIN ON THE THRONE, JEHOIAKIM, BUT NOW YOU MUST PAY TRIBUTE MONEY TO ME. AND TO SEE THAT YOU DO, I'LL TAKE YOUR BEST PRINCES AS HOSTAGES.

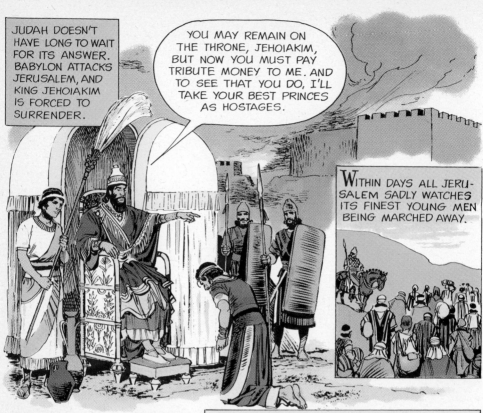

WITHIN DAYS ALL JERUSALEM SADLY WATCHES ITS FINEST YOUNG MEN BEING MARCHED AWAY.

KNOWING THAT THE DOWNFALL OF JUDAH IS NOT FAR OFF, JEREMIAH DICTATES ALL OF THE MESSAGES HE HAS RECEIVED FROM GOD.

THE PEOPLE MUST BE TOLD THAT GOD IS ALLOWING JUDAH TO BE PUNISHED FOR ITS SINS.

THEN--BECAUSE HE IS NOT ALLOWED IN THE TEMPLE--JEREMIAH ASKS BARUCH TO READ GOD'S WORD TO THE PEOPLE.

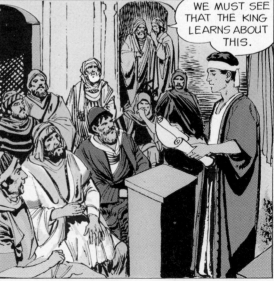

WE MUST SEE THAT THE KING LEARNS ABOUT THIS.

AS THE SCROLL IS READ TO THE KING, HE BECOMES SO ANGRY THAT HE CUTS IT UP PIECE BY PIECE AND THROWS IT INTO THE FIRE.

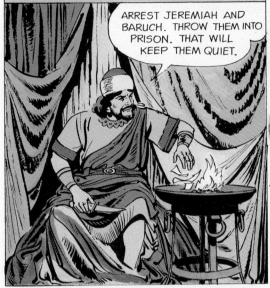

ARREST JEREMIAH AND BARUCH. THROW THEM INTO PRISON. THAT WILL KEEP THEM QUIET.

BUT JEREMIAH AND BARUCH ARE PREPARED FOR THE KING'S ANGER-- ALREADY THEY ARE IN HIDING.

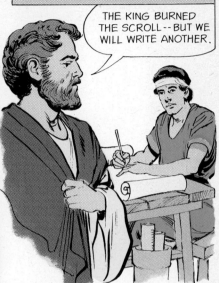

THE KING BURNED THE SCROLL -- BUT WE WILL WRITE ANOTHER.

WHILE JEREMIAH AND BARUCH ARE BUSY REPLACING THE BURNED SCROLL, TROUBLE IS BREWING IN THE PALACE.

WHY SHOULD WE PAY TRIBUTE TO BABYLON? I SAY LET'S STOP IT AND USE THE MONEY TO BUILD UP OUR OWN ARMY. THEN WE'LL BE READY IF BABYLON ATTACKS US AGAIN.

YOU'RE RIGHT-- THOSE HOSTAGES IN BABYLON ARE NOT AS IMPORTANT AS ALL OF US HERE IN JUDAH.

IN TIME, WORD LEAKS OUT THAT KING JEHOIAKIM IS BREAKING HIS AGREEMENT WITH BABYLON. JEREMIAH IS ALARMED.

THE KING'S DECISION IS AGAINST THE WILL OF GOD. AND NO MAN CAN DEFY GOD!

Rebellion

FROM II KINGS 24: 1-6;
Jeremiah 27; 28: 1-12; 37: 1-10.

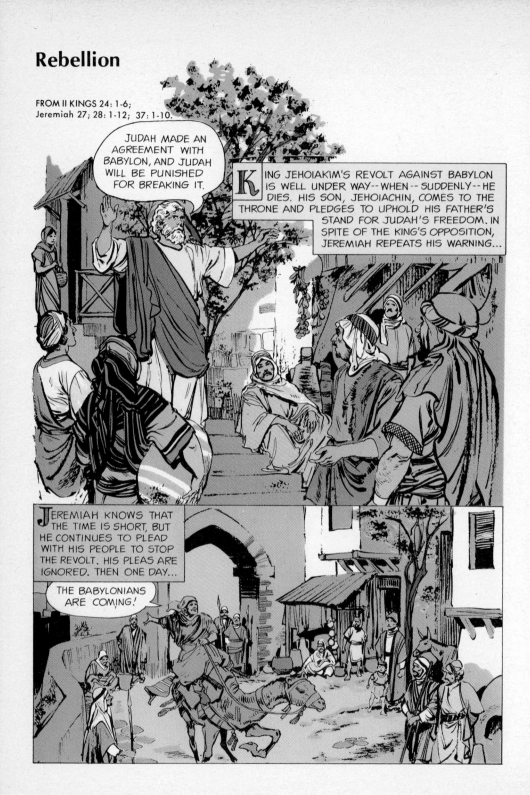

JUDAH MADE AN AGREEMENT WITH BABYLON, AND JUDAH WILL BE PUNISHED FOR BREAKING IT.

KING JEHOIAKIM'S REVOLT AGAINST BABYLON IS WELL UNDER WAY--WHEN--SUDDENLY--HE DIES. HIS SON, JEHOIACHIN, COMES TO THE THRONE AND PLEDGES TO UPHOLD HIS FATHER'S STAND FOR JUDAH'S FREEDOM. IN SPITE OF THE KING'S OPPOSITION, JEREMIAH REPEATS HIS WARNING...

JEREMIAH KNOWS THAT THE TIME IS SHORT, BUT HE CONTINUES TO PLEAD WITH HIS PEOPLE TO STOP THE REVOLT. HIS PLEAS ARE IGNORED. THEN ONE DAY...

THE BABYLONIANS ARE COMING!

WITH FULL FORCE THE ARMY OF BABYLON STORMS THE WALLS OF JERUSALEM.

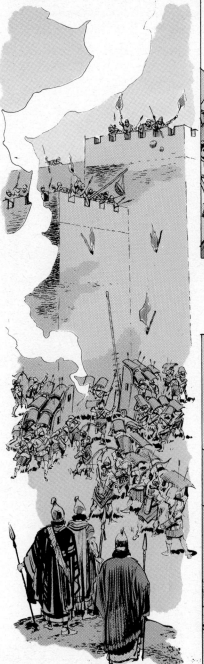

YOUNG KING JEHOIACHIN, WHO HAS RULED THREE MONTHS, IS FORCED TO SURRENDER TO KING NEBUCHADNEZZAR.

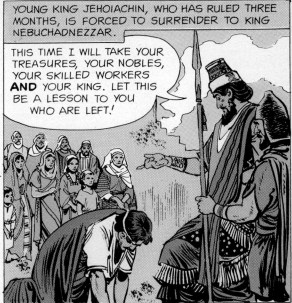

"THIS TIME I WILL TAKE YOUR TREASURES, YOUR NOBLES, YOUR SKILLED WORKERS **AND** YOUR KING. LET THIS BE A LESSON TO YOU WHO ARE LEFT.'

SO JEREMIAH'S PROPHECY COMES TRUE! THE TEMPLE TREASURES ARE LOOTED, THE KING AND 10,000 OF JUDAH'S ABLEST MEN ARE LED AWAY. PRINCE ZEDEKIAH IS MADE KING -- **AFTER** HE PROMISES LOYALTY TO BABYLON.

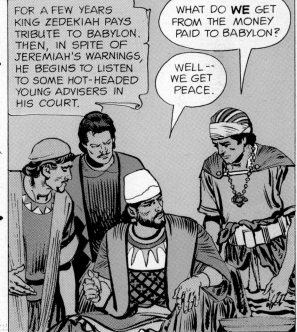

FOR A FEW YEARS KING ZEDEKIAH PAYS TRIBUTE TO BABYLON. THEN, IN SPITE OF JEREMIAH'S WARNINGS, HE BEGINS TO LISTEN TO SOME HOT-HEADED YOUNG ADVISERS IN HIS COURT.

WHAT DO **WE** GET FROM THE MONEY PAID TO BABYLON?

WELL -- WE GET PEACE.

Accused

FROM JEREMIAH 37—38: 6.

BACKED BY EGYPT'S PROMISE TO HELP, KING ZEDEKIAH OF JUDAH REVOLTS AGAINST THE CONTROL OF BABYLON. JEREMIAH ARGUES AGAINST THE DECISION.

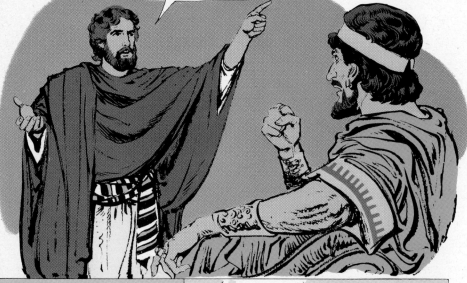

BABYLON HAS SPARED JERUSALEM TWICE BEFORE. BUT IF YOU GO THROUGH WITH THIS REVOLT, BABYLON WILL NOT SPARE THE CITY AGAIN.

BUT THIS TIME WE'LL WIN. JUDAH WILL BE FREE!

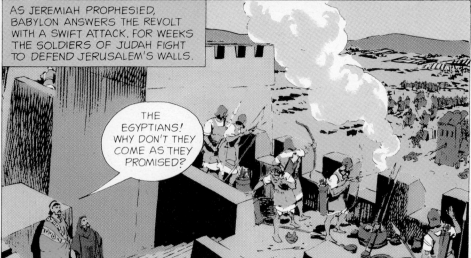

AS JEREMIAH PROPHESIED, BABYLON ANSWERS THE REVOLT WITH A SWIFT ATTACK. FOR WEEKS THE SOLDIERS OF JUDAH FIGHT TO DEFEND JERUSALEM'S WALLS.

THE EGYPTIANS! WHY DON'T THEY COME AS THEY PROMISED?

THEN -- SUDDENLY -- THE ATTACK CEASES...

THE BABYLONIANS ARE BREAKING CAMP-- THEY'VE GIVEN UP THE SIEGE!

WE'VE WON! JUDAH IS FREE!

LONG LIVE KING ZEDEKIAH!

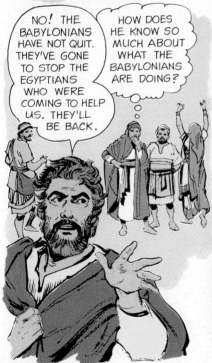

NO! THE BABYLONIANS HAVE NOT QUIT. THEY'VE GONE TO STOP THE EGYPTIANS WHO WERE COMING TO HELP US. THEY'LL BE BACK.

HOW DOES HE KNOW SO MUCH ABOUT WHAT THE BABYLONIANS ARE DOING?

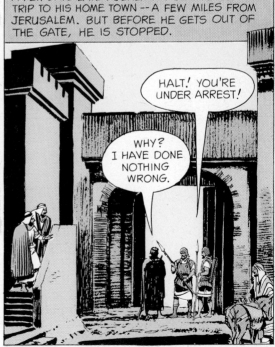

A FEW DAYS LATER JEREMIAH STARTS ON A TRIP TO HIS HOME TOWN -- A FEW MILES FROM JERUSALEM. BUT BEFORE HE GETS OUT OF THE GATE, HE IS STOPPED.

HALT! YOU'RE UNDER ARREST!

WHY? I HAVE DONE NOTHING WRONG.

IN SPITE OF HIS INNOCENCE, JEREMIAH IS THROWN INTO PRISON. WITHIN A FEW WEEKS THE BABYLONIANS, AFTER DEFEATING THE EGYPTIANS, RETURN TO THE GATES OF JERUSALEM. JEREMIAH'S ENEMIES BRING HIM BEFORE THE KING AND ACCUSE HIM OF BEING A TRAITOR.

I REPEAT THE WARNING GOD HAS GIVEN ME. INVADERS FROM THE NORTH WILL CONQUER JUDAH. GOD HAS CHOSEN THE BABYLONIANS TO DESTROY OUR NATION BECAUSE OF THE SINS OF ITS PEOPLE.

IT'S THIS KIND OF TALK THAT MAKES OUR SOLDIERS LOSE COURAGE. PUT THIS TRAITOR TO DEATH-- OR THE CITY **WILL** FALL.

HE IS IN YOUR HANDS-- DO WHAT YOU WANT WITH HIM.

QUICKLY-- BEFORE THE KING CAN CHANGE HIS MIND-- JEREMIAH IS PUT INTO AN OLD CISTERN BENEATH THE PRISON FLOOR.

LET HIM STARVE TO DEATH!

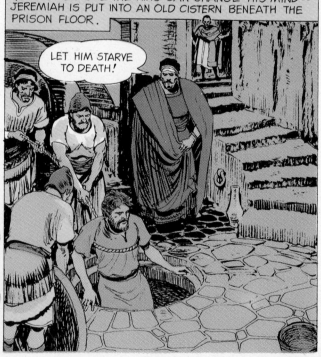

A Prophecy Comes True

FROM JEREMIAH 38: 7—43: 7.

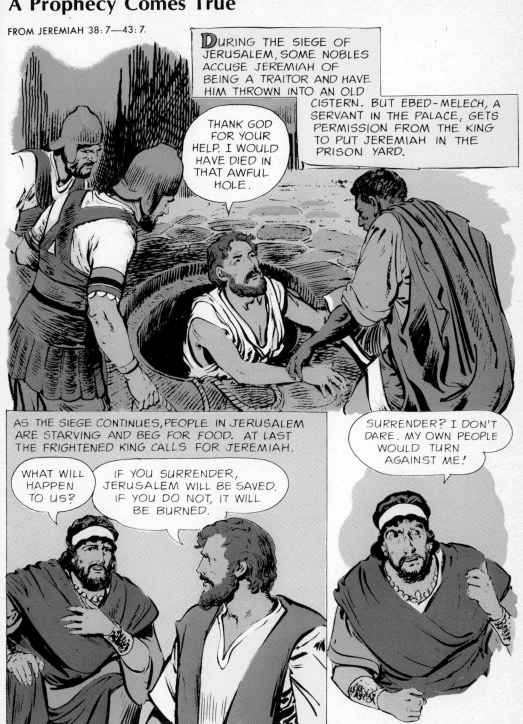

DURING THE SIEGE OF JERUSALEM, SOME NOBLES ACCUSE JEREMIAH OF BEING A TRAITOR AND HAVE HIM THROWN INTO AN OLD CISTERN. BUT EBED-MELECH, A SERVANT IN THE PALACE, GETS PERMISSION FROM THE KING TO PUT JEREMIAH IN THE PRISON YARD.

THANK GOD FOR YOUR HELP. I WOULD HAVE DIED IN THAT AWFUL HOLE.

AS THE SIEGE CONTINUES, PEOPLE IN JERUSALEM ARE STARVING AND BEG FOR FOOD. AT LAST THE FRIGHTENED KING CALLS FOR JEREMIAH.

WHAT WILL HAPPEN TO US?

IF YOU SURRENDER, JERUSALEM WILL BE SAVED. IF YOU DO NOT, IT WILL BE BURNED.

SURRENDER? I DON'T DARE. MY OWN PEOPLE WOULD TURN AGAINST ME!

THE BABYLONIANS HAVE BROKEN THROUGH THE WALL!

JERUSALEM WILL BE DESTROYED! BUT IT WILL RISE AGAIN... AND SOMEDAY GOD'S COMMANDMENTS WILL BE WRITTEN IN THE HEARTS OF MEN WHO CHOOSE TO OBEY GOD. THEY WILL LIVE TOGETHER IN PEACE.

KING ZEDEKIAH TRIES TO ESCAPE, BUT IS CAPTURED AND BLINDED. THE KING, JEREMIAH, AND MOST OF THE ABLE-BODIED PEOPLE ARE CAPTURED TO BE TAKEN TO BABYLON.

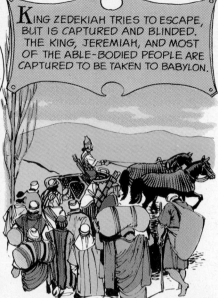

BUT IN THE CAPTIVE CAMP AT RAMAH...

THE KING OF BABYLON HAS LEARNED THAT YOU TRIED TO KEEP YOUR COUNTRY FROM REBELLING AGAINST HIM, SO HE HAS SENT ORDERS TO SET YOU FREE.

THANK GOD! NOW I CAN HELP THE PEOPLE WHO HAVE BEEN LEFT IN ISRAEL WITHOUT A LEADER.

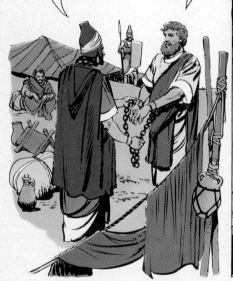

ABOUT A MONTH AFTER JERUSALEM IS TAKEN, A BABYLONIAN OFFICER RETURNS, TAKES MORE CAPTIVES, AND THEN SETS FIRE TO THE CITY.

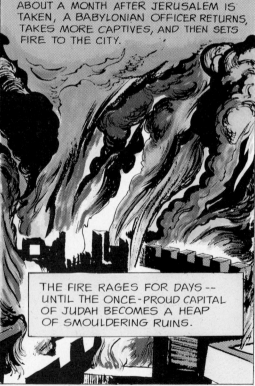

THE FIRE RAGES FOR DAYS -- UNTIL THE ONCE-PROUD CAPITAL OF JUDAH BECOMES A HEAP OF SMOULDERING RUINS.

THE BABYLONIANS SET UP HEADQUARTERS AT MIZPAH AND APPOINT AN ISRAELITE TO ACT AS GOVERNOR. JEREMIAH JOINS HIM -- AND BECOMES HIS ADVISER.

TOGETHER WE'LL ENCOURAGE THE PEOPLE TO BUILD UP THEIR HOMES AND REPLANT THEIR VINEYARDS AND FIELDS.

SOMEDAY THE CAPTIVES WILL RETURN-- AND JUDAH WILL BECOME A NATION AGAIN.

BUT BEFORE THE GOVERNOR'S DREAM CAN COME TRUE HE IS MURDERED BY SOME ISRAELITES WHO ARE JEALOUS OF HIS POWER IN THE COUNTRY. FEARFUL THAT BABYLON WILL BLAME ALL ISRAEL FOR THE MURDER, A GROUP OF PEOPLE GO TO JEREMIAH...

WE WANT TO GO TO EGYPT-- WHERE THERE IS PEACE AND PLENTY TO EAT.

YOU WILL FIND NEITHER PEACE NOR PLENTY IN EGYPT. STAY HERE -- THE BABYLONIANS WILL NOT HURT YOU.

BUT THE PEOPLE DO NOT BELIEVE JEREMIAH. THEY FLEE TO EGYPT, FORCING HIM TO GO WITH THEM. AND THERE, UNTIL HE DIES, JEREMIAH TRIES TO LEAD HIS PEOPLE BACK TO GOD.

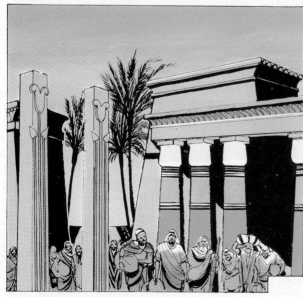

THE GRIEF OF THE JEWS OVER THE DESTRUCTION OF JERUSALEM IS EXPRESSED IN A GROUP OF POEMS FOUND IN THE

BOOK OF LAMENTATIONS

Ten Thousand Captives

FROM EZEKIEL 1

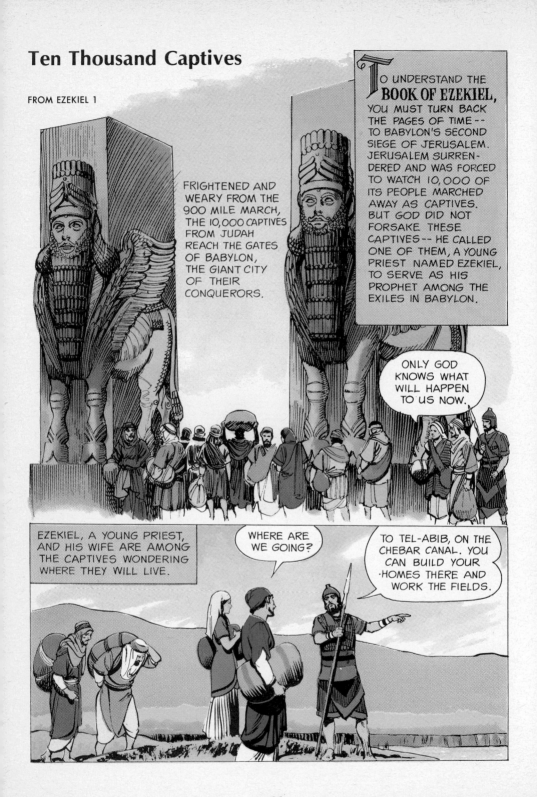

TO UNDERSTAND THE **BOOK OF EZEKIEL,** YOU MUST TURN BACK THE PAGES OF TIME -- TO BABYLON'S SECOND SIEGE OF JERUSALEM. JERUSALEM SURRENDERED AND WAS FORCED TO WATCH 10,000 OF ITS PEOPLE MARCHED AWAY AS CAPTIVES. BUT GOD DID NOT FORSAKE THESE CAPTIVES -- HE CALLED ONE OF THEM, A YOUNG PRIEST NAMED EZEKIEL, TO SERVE AS HIS PROPHET AMONG THE EXILES IN BABYLON.

FRIGHTENED AND WEARY FROM THE 900 MILE MARCH, THE 10,000 CAPTIVES FROM JUDAH REACH THE GATES OF BABYLON, THE GIANT CITY OF THEIR CONQUERORS.

ONLY GOD KNOWS WHAT WILL HAPPEN TO US NOW.

EZEKIEL, A YOUNG PRIEST, AND HIS WIFE ARE AMONG THE CAPTIVES WONDERING WHERE THEY WILL LIVE.

WHERE ARE WE GOING?

TO TEL-ABIB, ON THE CHEBAR CANAL. YOU CAN BUILD YOUR HOMES THERE AND WORK THE FIELDS.

IN THE MONTHS THAT FOLLOW, EZEKIEL WORKS HARD TO MAKE A LIVING IN THE NEW LAND.

IT IS NOT AS BAD AS I FEARED. WE ARE WELL TREATED--AND WE ARE TOGETHER.

YES. WE MAY HAVE TO STAY HERE THE REST OF OUR LIVES, BUT GOD IS WITH US WHEREVER WE ARE.

BUT NOT ALL OF THE CAPTIVES FEEL THE SAME WAY.

WHAT DO YOU THINK OF EZEKIEL PLANTING TREES AND PLANNING TO BUILD A HOUSE? LOOKS AS IF HE INTENDS TO STAY IN BABYLONIA.

HE'S WASTING HIS TIME. WE'LL BE ON OUR WAY HOME IN A COUPLE OF YEARS.

WHEN THIS NEWS REACHES GOD'S PROPHET, JEREMIAH, IN JUDAH, HE WRITES A LETTER TO THE CAPTIVES.

JEREMIAH SAYS IT IS GOD'S WILL THAT WE STAY HERE. WE SHOULD BUILD HOMES AND WORK FOR THE GOOD OF OUR NEW COUNTRY. WE WILL BE HERE FOR SEVENTY YEARS.

DID YOU HEAR THAT, EZEKIEL? SEVENTY YEARS --I DON'T BELIEVE IT!

JEREMIAH SPEAKS THE WILL OF GOD.

EZEKIEL SHOWS HIS FAITH BY BUILDING A HOUSE.

WE'LL MAKE A LARGE COURTYARD--BIG ENOUGH TO INVITE PEOPLE HERE TO WORSHIP GOD. I USED TO THINK THAT WE COULD WORSHIP GOD ONLY IN THE TEMPLE IN JERUSALEM, BUT NOW I KNOW WE CAN WORSHIP HIM ANYWHERE.

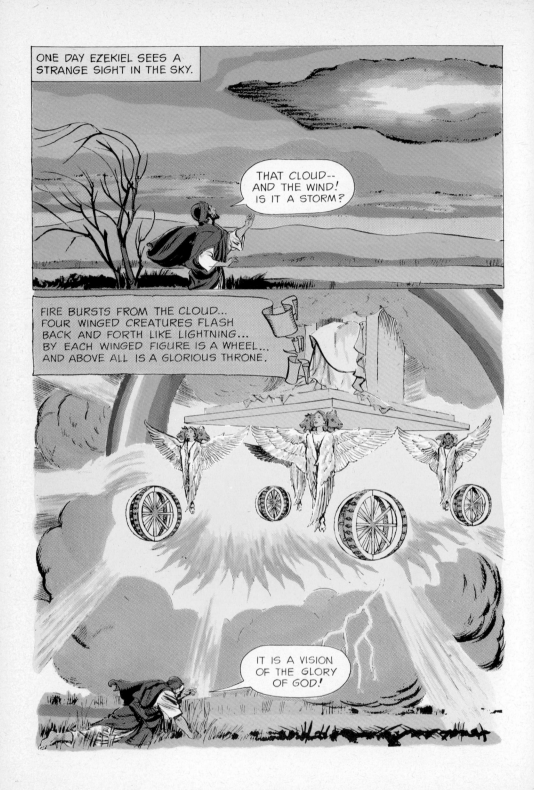

100

A Message of Hope

FROM EZEKIEL 1—48

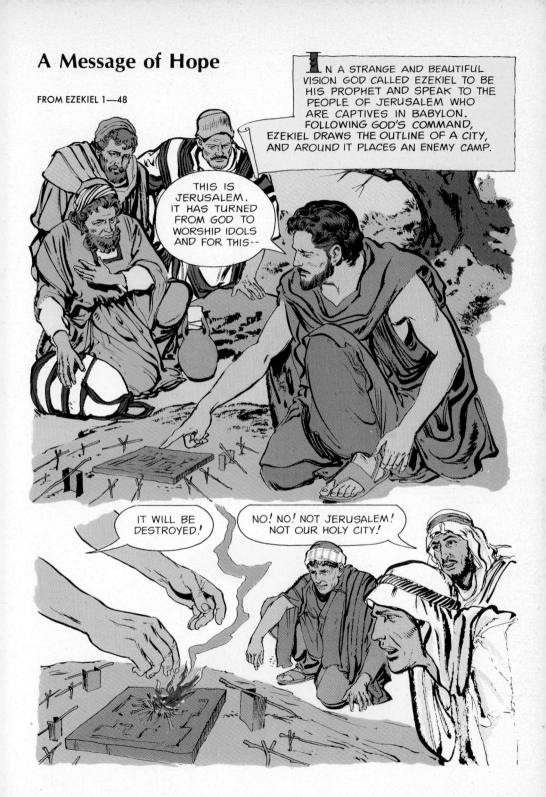

IN A STRANGE AND BEAUTIFUL VISION GOD CALLED EZEKIEL TO BE HIS PROPHET AND SPEAK TO THE PEOPLE OF JERUSALEM WHO ARE CAPTIVES IN BABYLON. FOLLOWING GOD'S COMMAND, EZEKIEL DRAWS THE OUTLINE OF A CITY, AND AROUND IT PLACES AN ENEMY CAMP.

THIS IS JERUSALEM. IT HAS TURNED FROM GOD TO WORSHIP IDOLS AND FOR THIS--

IT WILL BE DESTROYED!

NO! NO! NOT JERUSALEM! NOT OUR HOLY CITY!

EZEKIEL KEEPS WARNING THE PEOPLE THAT JERUSALEM WILL BE DESTROYED, BUT THEY REFUSE TO BELIEVE HIM. THEN -- SUDDENLY -- EZEKIEL'S WIFE DIES. BUT THE PROPHET SHOWS NO OUTWARD SIGN OF GRIEF.

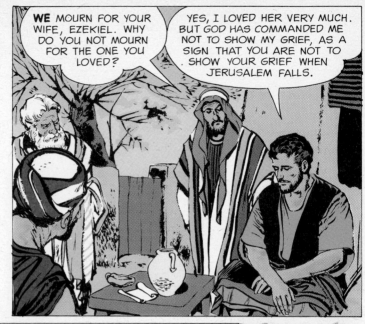

WE MOURN FOR YOUR WIFE, EZEKIEL. WHY DO YOU NOT MOURN FOR THE ONE YOU LOVED?

YES, I LOVED HER VERY MUCH. BUT GOD HAS COMMANDED ME NOT TO SHOW MY GRIEF, AS A SIGN THAT YOU ARE NOT TO SHOW YOUR GRIEF WHEN JERUSALEM FALLS.

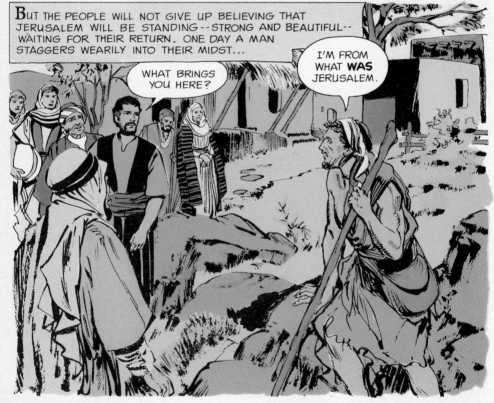

BUT THE PEOPLE WILL NOT GIVE UP BELIEVING THAT JERUSALEM WILL BE STANDING -- STRONG AND BEAUTIFUL -- WAITING FOR THEIR RETURN. ONE DAY A MAN STAGGERS WEARILY INTO THEIR MIDST...

WHAT BRINGS YOU HERE?

I'M FROM WHAT **WAS** JERUSALEM.

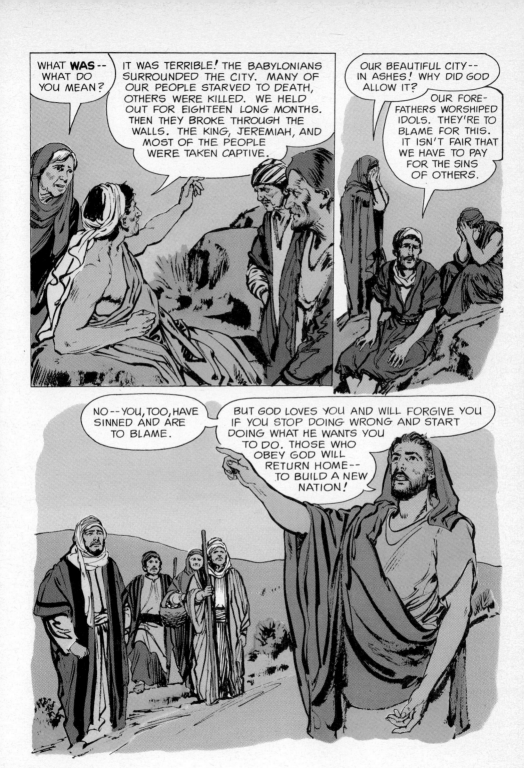

Captives in Babylon

FROM DANIEL 1—2:13

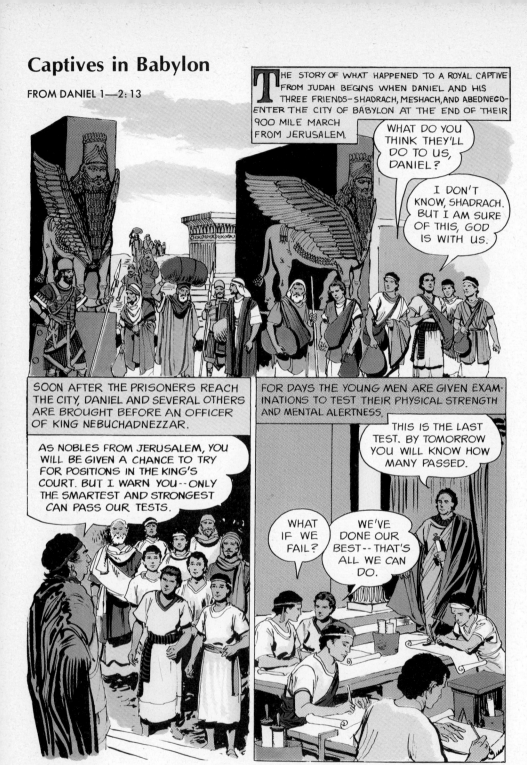

THE STORY OF WHAT HAPPENED TO A ROYAL CAPTIVE FROM JUDAH BEGINS WHEN DANIEL AND HIS THREE FRIENDS—SHADRACH, MESHACH, AND ABEDNEGO—ENTER THE CITY OF BABYLON AT THE END OF THEIR 900 MILE MARCH FROM JERUSALEM.

WHAT DO YOU THINK THEY'LL DO TO US, DANIEL?

I DON'T KNOW, SHADRACH. BUT I AM SURE OF THIS, GOD IS WITH US.

SOON AFTER THE PRISONERS REACH THE CITY, DANIEL AND SEVERAL OTHERS ARE BROUGHT BEFORE AN OFFICER OF KING NEBUCHADNEZZAR.

AS NOBLES FROM JERUSALEM, YOU WILL BE GIVEN A CHANCE TO TRY FOR POSITIONS IN THE KING'S COURT. BUT I WARN YOU—ONLY THE SMARTEST AND STRONGEST CAN PASS OUR TESTS.

FOR DAYS THE YOUNG MEN ARE GIVEN EXAMINATIONS TO TEST THEIR PHYSICAL STRENGTH AND MENTAL ALERTNESS.

THIS IS THE LAST TEST. BY TOMORROW YOU WILL KNOW HOW MANY PASSED.

WHAT IF WE FAIL?

WE'VE DONE OUR BEST—THAT'S ALL WE CAN DO.

THE NEXT DAY...

YOU HAVE ALL PASSED -- NOW YOU'LL BE GIVEN THREE YEARS TO STUDY UNDER OUR WISE MEN. AFTER THAT THE KING HIMSELF WILL CHOOSE THOSE BEST QUALIFIED TO BE HIS ADVISERS.

O GOD, THANK YOU. HELP US TO PASS THESE NEW TESTS SO THAT WE MAY ADVISE THE KING IN A WAY THAT WILL PLEASE YOU.

THE YOUNG MEN ARE TAKEN AT ONCE TO THE PALACE TO BEGIN THEIR STUDIES. THEY ARE GIVEN THE BEST OF EVERYTHING -- EVEN FOOD FROM THE KING'S TABLE.

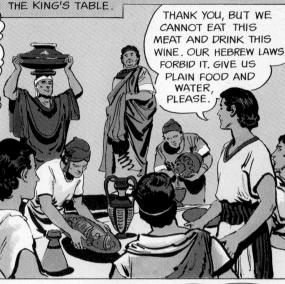

THANK YOU, BUT WE CANNOT EAT THIS MEAT AND DRINK THIS WINE. OUR HEBREW LAWS FORBID IT. GIVE US PLAIN FOOD AND WATER, PLEASE.

BUT IT'S THE KING'S ORDER -- WE DARE NOT DISOBEY. I LIKE YOU, DANIEL, BUT I DON'T WANT TO GET INTO TROUBLE.

GIVE US A TEN-DAY TRIAL. LET US EAT OUR FOOD AND THEN SEE IF WE ARE NOT STRONGER THAN THE OTHERS.

THE TEST IS MADE, AND AT THE END OF TEN DAYS, THERE'S NO DOUBT--DANIEL AND HIS FRIENDS NOT ONLY **LOOK** STRONGER, THEY **ARE** STRONGER.

AT THE END OF THREE YEARS, THE YOUNG MEN ARE BROUGHT BEFORE THE KING. HE TALKS WITH EACH ONE, THEN MAKES HIS DECISION.

I HAVE CHOSEN THESE FOUR--DANIEL, SHADRACH, MESHACH, AND ABEDNEGO -- TO SERVE AS MY ADVISERS.

THERE IS NONE TO EQUAL THEM, SIR.

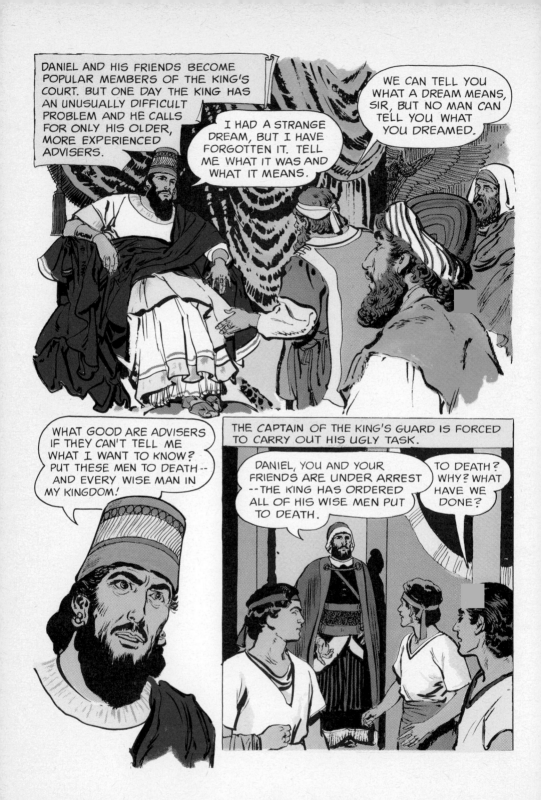

The Statue

FROM DANIEL 2: 16-48

KING NEBUCHADNEZZAR IS FURIOUS! HIS WISE MEN CANNOT TELL HIM WHAT HE HAS DREAMED. SO HE ORDERS ALL OF THEM PUT TO DEATH—INCLUDING DANIEL AND HIS THREE FRIENDS, SHADRACH, MESHACH, AND ABEDNEGO. DANIEL ASKS FOR PERMISSION TO SPEAK TO THE KING.

YOU HAVE UNTIL TOMORROW AT THIS HOUR—BUT NOT ONE MINUTE MORE.

O KING, GIVE ME TIME AND I WILL TELL YOU WHAT YOU DREAMED.

DANIEL RUSHES BACK TO HIS FRIENDS WITH THE GOOD NEWS.

BUT, DANIEL, NO MAN ON EARTH CAN DO WHAT YOU HAVE PROMISED TO DO.

YOU ARE RIGHT—NO MAN CAN DO IT, BUT GOD CAN. AND WE WILL ASK HIM TO GIVE US THE ANSWER.

AS THE FOUR YOUNG HEBREWS PRAY, A VISION COMES TO DANIEL.

O GOD, THANK YOU FOR MAKING THE DREAM KNOWN TO ME.

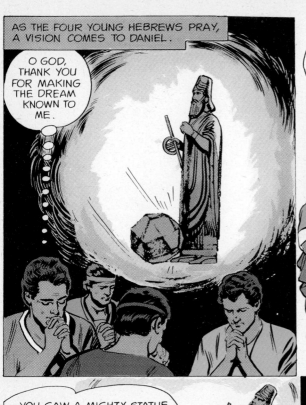

THE NEXT DAY--

HAVE YOU COME TO ASK FOR MORE TIME -- OR CAN YOU TELL ME MY DREAM?

GOD IN HEAVEN HAS REVEALED YOUR DREAM TO ME.

YOU SAW A MIGHTY STATUE -- ITS HEAD WAS MADE OF GOLD AND ITS FEET OF CLAY. THEN YOU SAW A LARGE STONE STRIKE AT THE FEET OF THE STATUE AND BREAK IT INTO MANY PIECES.

YES! YES! THAT'S RIGHT. BUT WHAT DOES IT MEAN?

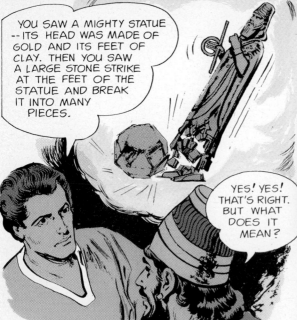

THE HEAD OF GOLD STANDS FOR YOU AND YOUR GREAT KINGDOM, O KING. OTHER LESSER KINGDOMS WILL FOLLOW. BUT AFTER THEY FALL, GOD WILL SET UP A KINGDOM WHICH SHALL NEVER BE DESTROYED.

YOUR GOD IS A GOD ABOVE ALL GODS. AND YOU SHALL BE RULER OF THE PROVINCE OF BABYLON -- OVER ALL THE WISE MEN WHOSE LIVES YOU SAVED THIS DAY.

DANIEL RELAYS THE GOOD NEWS TO HIS HEBREW FRIENDS.

THE KING HAS MADE ME RULER OVER BABYLON AND EACH OF YOU HAS AN IMPORTANT OFFICE IN THE KINGDOM.

THAT'S WONDERFUL!

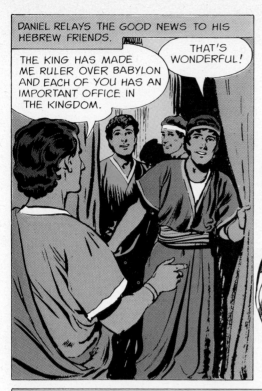

BUT THE NEWS DOES NOT PLEASE THE KING'S OTHER ADVISERS.

SO THE KING HAS PUT THIS YOUNG HEBREW OVER **US!** WE MUST GET RID OF HIM.

NOT NOW-- HE'S TOO POWERFUL! BUT IF WE CAN TURN THE KING AGAINST DANIEL'S FRIENDS, WE MIGHT BE ABLE TO CAUSE DANIEL TROUBLE.

THEIR OPPORTUNITY COMES WHEN THE KING BUILDS A STATUE AND ORDERS HIS OFFICIALS TO WORSHIP IT--OR BE THROWN INTO A FIERY FURNACE.

THE KING IS PLAYING RIGHT INTO OUR HANDS --HE DOESN'T KNOW THAT HEBREWS WILL WORSHIP ONLY THEIR GOD.

DANIEL HOLDS TOO HIGH A POSITION FOR ANY ONE OF US TO REPORT ON HIM-- BUT NOT HIS FRIENDS...

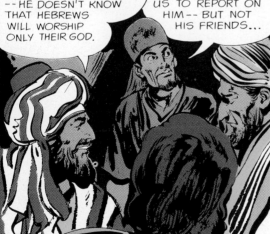

RIGHT--AND TOMORROW WHEN THE TRUMPET SOUNDS FOR ALL MEN TO BOW BEFORE THE STATUE, WE'LL KEEP OUR EYES ON SHADRACH, MESHACH, AND ABEDNEGO.

Trial by Fire
FROM DANIEL 3: 1-25

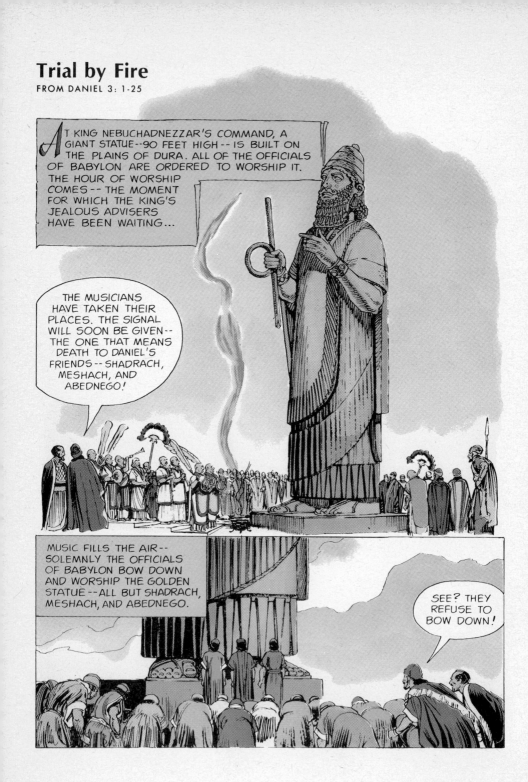

AT KING NEBUCHADNEZZAR'S COMMAND, A GIANT STATUE--90 FEET HIGH--IS BUILT ON THE PLAINS OF DURA. ALL OF THE OFFICIALS OF BABYLON ARE ORDERED TO WORSHIP IT. THE HOUR OF WORSHIP COMES-- THE MOMENT FOR WHICH THE KING'S JEALOUS ADVISERS HAVE BEEN WAITING...

THE MUSICIANS HAVE TAKEN THEIR PLACES. THE SIGNAL WILL SOON BE GIVEN-- THE ONE THAT MEANS DEATH TO DANIEL'S FRIENDS-- SHADRACH, MESHACH, AND ABEDNEGO!

MUSIC FILLS THE AIR-- SOLEMNLY THE OFFICIALS OF BABYLON BOW DOWN AND WORSHIP THE GOLDEN STATUE--ALL BUT SHADRACH, MESHACH, AND ABEDNEGO.

SEE? THEY REFUSE TO BOW DOWN!

EAGERLY, THE JEALOUS ADVISERS REPORT TO THE KING.

O KING, THREE OF YOUR HEBREW OFFICIALS HAVE DEFIED YOU. THEY REFUSE TO WORSHIP YOUR STATUE.

WHAT? HAVE THEM BROUGHT TO ME AT ONCE!

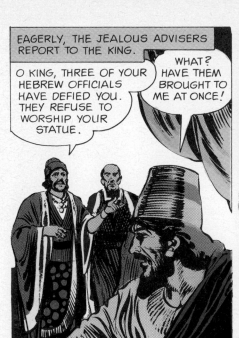

WORSHIP THE STATUE -- OR BE THROWN INTO THE FIERY FURNACE. AND TELL ME -- WHAT GOD CAN SAVE YOU FROM THAT?

IF WE ARE CAST INTO THE FIRE, THE GOD WHOM WE SERVE WILL BE ABLE TO DELIVER US! BUT EVEN IF WE MUST DIE, WE WILL NOT WORSHIP AN IDOL.

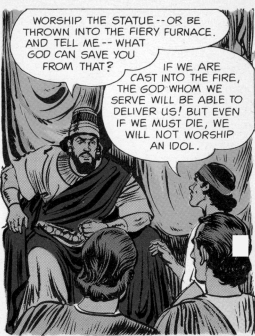

HEAT THE FURNACE -- SEVEN TIMES - HOTTER THAN EVER BEFORE -- AND THROW THEM IN IT!

THE THREE HEBREWS ARE QUICKLY BOUND AND THROWN INTO THE RAGING FIRE.

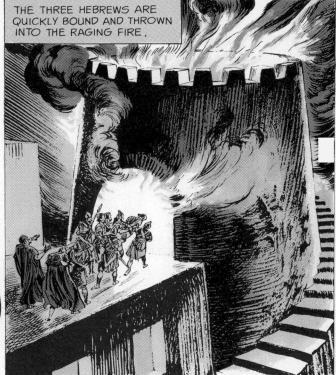

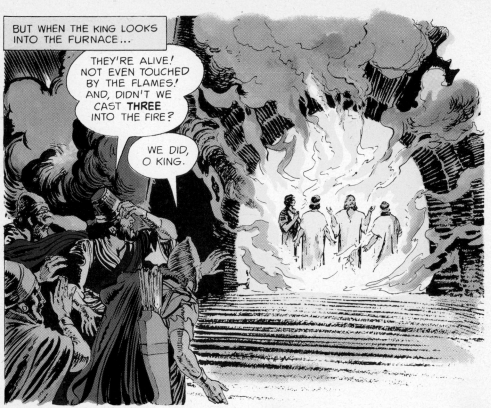

BUT WHEN THE KING LOOKS INTO THE FURNACE...

THEY'RE ALIVE! NOT EVEN TOUCHED BY THE FLAMES! AND, DIDN'T WE CAST **THREE** INTO THE FIRE?

WE DID, O KING.

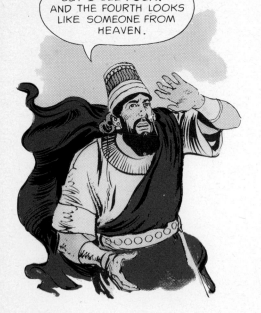

BUT I SEE **FOUR!** AND THE FOURTH LOOKS LIKE SOMEONE FROM HEAVEN.

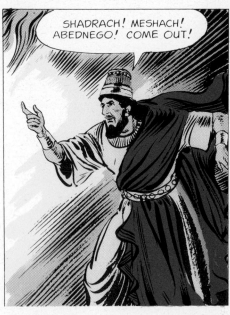

SHADRACH! MESHACH! ABEDNEGO! COME OUT!

112

A King's Boast

FROM DANIEL 3:26—5:6

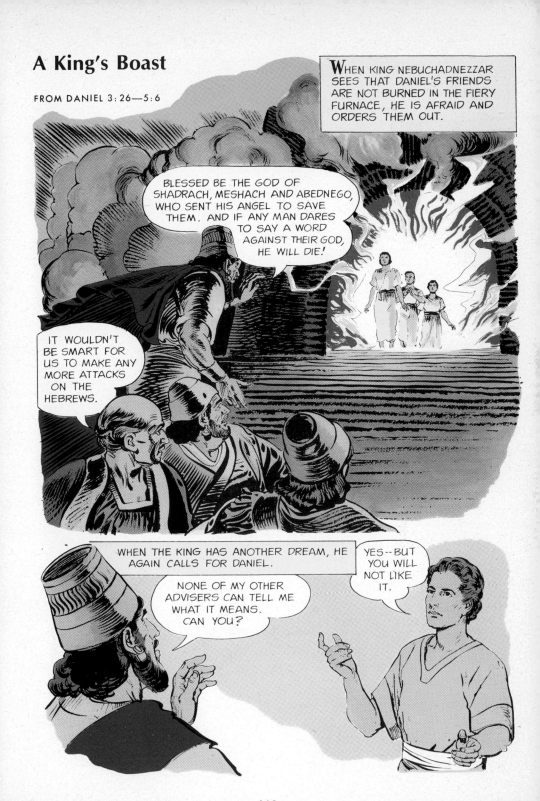

WHEN KING NEBUCHADNEZZAR SEES THAT DANIEL'S FRIENDS ARE NOT BURNED IN THE FIERY FURNACE, HE IS AFRAID AND ORDERS THEM OUT.

BLESSED BE THE GOD OF SHADRACH, MESHACH AND ABEDNEGO, WHO SENT HIS ANGEL TO SAVE THEM. AND IF ANY MAN DARES TO SAY A WORD AGAINST THEIR GOD, HE WILL DIE!

IT WOULDN'T BE SMART FOR US TO MAKE ANY MORE ATTACKS ON THE HEBREWS.

WHEN THE KING HAS ANOTHER DREAM, HE AGAIN CALLS FOR DANIEL.

NONE OF MY OTHER ADVISERS CAN TELL ME WHAT IT MEANS. CAN YOU?

YES--BUT YOU WILL NOT LIKE IT.

THE TREE YOU DREAMED ABOUT IS YOU, O KING-- TALL, STRONG, AND PROUD. YOU SAW THE TREE CUT DOWN. THIS MEANS THAT YOUR POWER AS KING WILL BE TAKEN FROM YOU IF YOU DO NOT HONOUR GOD ABOVE YOURSELF.

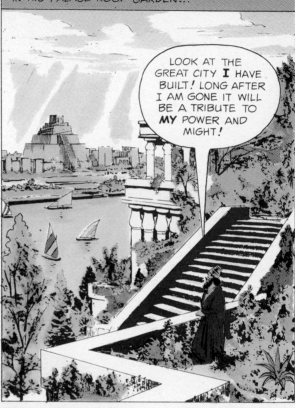

THE KING IS UPSET BY WHAT DANIEL SAYS, BUT IN TIME HE FORGETS... ONE DAY AS HE WALKS IN HIS PALACE ROOF GARDEN...

LOOK AT THE GREAT CITY **I** HAVE BUILT! LONG AFTER I AM GONE IT WILL BE A TRIBUTE TO **MY** POWER AND MIGHT!

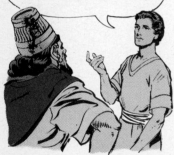

AS THE BOASTFUL WORDS ARE SPOKEN, DANIEL'S WARNING COMES TRUE. THE KING LOSES HIS MIND-- AND FOR SEVEN YEARS HE LIVES LIKE A BEAST OF THE FIELD. THEN ONE DAY THE KING REALIZES HE IS BEING PUNISHED FOR FAILING TO HONOUR GOD

O GOD OF DANIEL AND THE HEBREWS, I HONOUR AND PRAISE THEE, WHOSE KINGDOM IS GREAT AND EVERLASTING-- WHOSE WORK IS TRUTH AND JUSTICE.

INSTANTLY KING
NEBUCHADNEZZAR'S
MIND IS RESTORED.
HE RETURNS TO THE
THRONE AND RULES
WISELY WITH DANIEL
AS HIS ADVISER.

BUT AFTER HIS
DEATH THE RULERS
WHO FOLLOW HIM
TURN AWAY FROM
DANIEL. ONE OF
THEM, BELSHAZZAR,
IS SO SURE OF HIS
OWN WISDOM THAT...

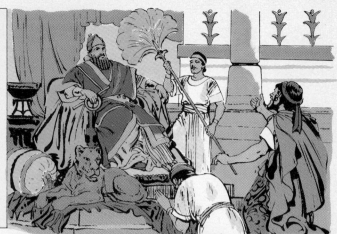

HE LAUGHS AT TWO GREAT THREATS TO HIS
KINGDOM: ANGRY PRIESTS WHO ARE TURNING AGAINST
HIM, AND THE APPROACH OF THE MIGHTY PERSIAN
ARMY. INSTEAD, HE PREPARES A GREAT FEAST TO
WHICH HE INVITES A THOUSAND GUESTS...

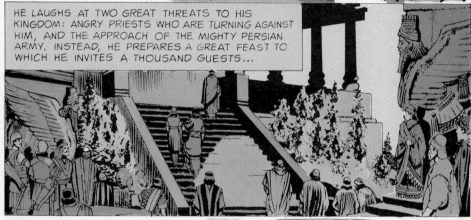

THE PARTY IS AT ITS MERRIEST
WHEN SUDDENLY BELSHAZZAR
STARES AT A PLACE HIGH ON
THE BANQUET WALL. HE TURNS
PALE-- HIS HANDS TREMBLE...

LOOK! ON THE WALL!
WHAT IS IT? WHAT
DOES IT MEAN?

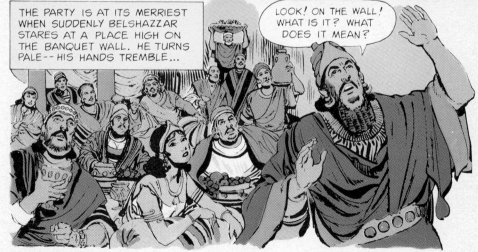

Handwriting on the Wall

FROM DANIEL 5: 7—6: 14

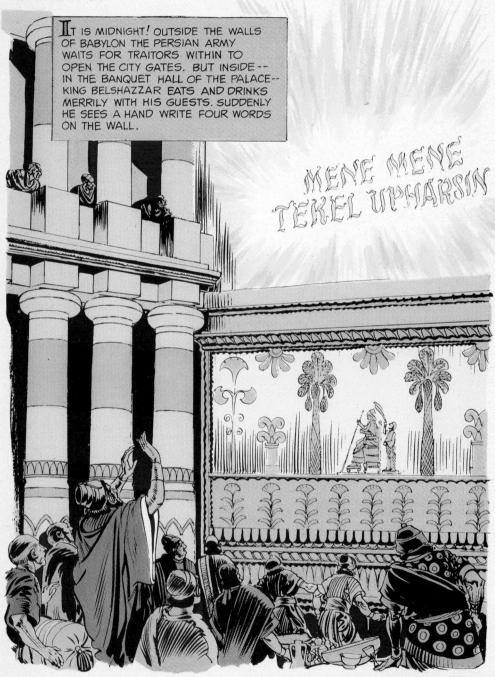

It is midnight! Outside the walls of Babylon the Persian army waits for traitors within to open the city gates. But inside -- in the banquet hall of the palace -- King Belshazzar eats and drinks merrily with his guests. Suddenly he sees a hand write four words on the wall.

MENE MENE TEKEL UPHARSIN

TERRIFIED, BELSHAZZAR CALLS FOR HIS ADVISERS TO EXPLAIN THE WORDS, BUT THEY CANNOT. WHEN THE KING'S MOTHER HEARS THE EXCITEMENT IN THE BANQUET HALL SHE RUSHES TO HER SON.

MY SON, THERE'S A MAN IN YOUR KINGDOM NAMED DANIEL WHO CAN INTERPRET DREAMS. CALL HIM.

DANIEL! YES! YES! BRING HIM HERE AT ONCE!

NOT A SOUND IS HEARD IN THE GREAT BANQUET HALL UNTIL DANIEL APPEARS BEFORE THE KING.

TELL ME WHAT THOSE WORDS MEAN AND YOU SHALL BE SECOND ONLY TO ME IN ALL BABYLON.

O KING, THEY ARE A WARNING FROM GOD. YOU HAVE BEEN MEASURED AND FOUND LACKING IN THE QUALITIES OF A RULER. YOUR KINGDOM WILL BE GIVEN TO THE PERSIANS.

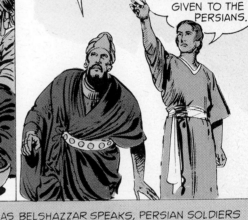

I DON'T BELIEVE YOUR MESSAGE, BUT I'LL KEEP MY PROMISE. HERE, THIS CHAIN MAKES YOU NEXT TO ME IN ALL THE KINGDOM. NOW, ON WITH THE FEAST!

AS BELSHAZZAR SPEAKS, PERSIAN SOLDIERS SUDDENLY FILL THE HALL--AND TAKE HIM PRISONER.

SOLDIERS? WHERE DID THEY COME FROM? MY GUARDS! WHERE ARE MY GUARDS?

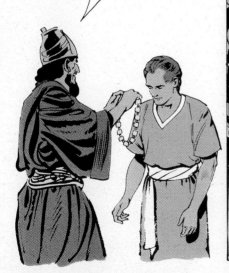

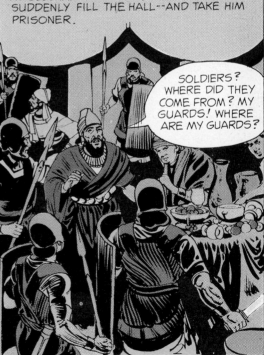

BEFORE MORNING THE CITY IS IN THE HANDS OF THE ENEMY. BELSHAZZAR IS KILLED. DANIEL IS BROUGHT BEFORE DARIUS, THE COMMANDER, WHO RECOGNIZES DANIEL'S ABILITY AS A LEADER.

YOU WILL RULE OVER MY NOBLES AS LONG AS YOU OBEY ME.

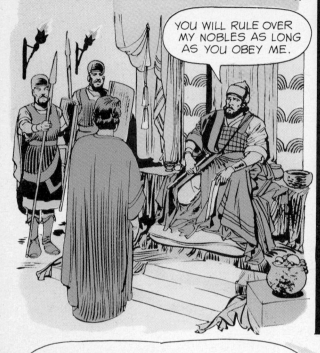

DARIUS FINDS DANIEL VERY WISE AND OFTEN TURNS TO HIM FOR ADVICE.

DARIUS HAS APPOINTED DANIEL RULER OVER ALL OF US.

WE MUST GET RID OF HIM-- AND I KNOW JUST HOW TO DO IT!

O KING, YOUR NOBLES, WHO HONOUR YOU ABOVE ALL, BEG YOU TO SIGN THIS LAW SO THAT **EVERYONE** WILL HONOUR YOU. IT FORBIDS ANYONE TO BOW DOWN TO ANY GOD OR MAN BUT YOU, FOR THIRTY DAYS.

IF YOU WANT SUCH A LAW, I'LL SIGN IT.

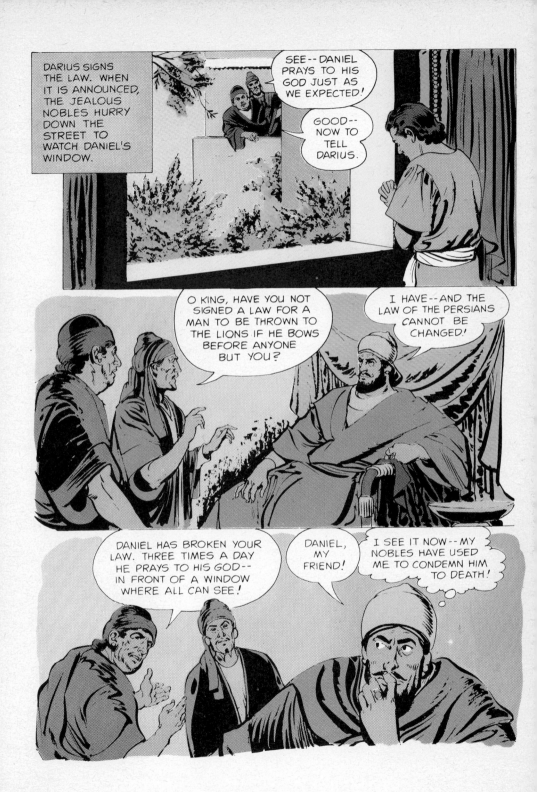

DARIUS SIGNS THE LAW. WHEN IT IS ANNOUNCED, THE JEALOUS NOBLES HURRY DOWN THE STREET TO WATCH DANIEL'S WINDOW.

SEE -- DANIEL PRAYS TO HIS GOD JUST AS WE EXPECTED!

GOOD -- NOW TO TELL DARIUS.

O KING, HAVE YOU NOT SIGNED A LAW FOR A MAN TO BE THROWN TO THE LIONS IF HE BOWS BEFORE ANYONE BUT YOU?

I HAVE -- AND THE LAW OF THE PERSIANS CANNOT BE CHANGED!

DANIEL HAS BROKEN YOUR LAW. THREE TIMES A DAY HE PRAYS TO HIS GOD -- IN FRONT OF A WINDOW WHERE ALL CAN SEE!

DANIEL, MY FRIEND!

I SEE IT NOW -- MY NOBLES HAVE USED ME TO CONDEMN HIM TO DEATH!

The Lions' Den

FROM DANIEL 6: 16-28

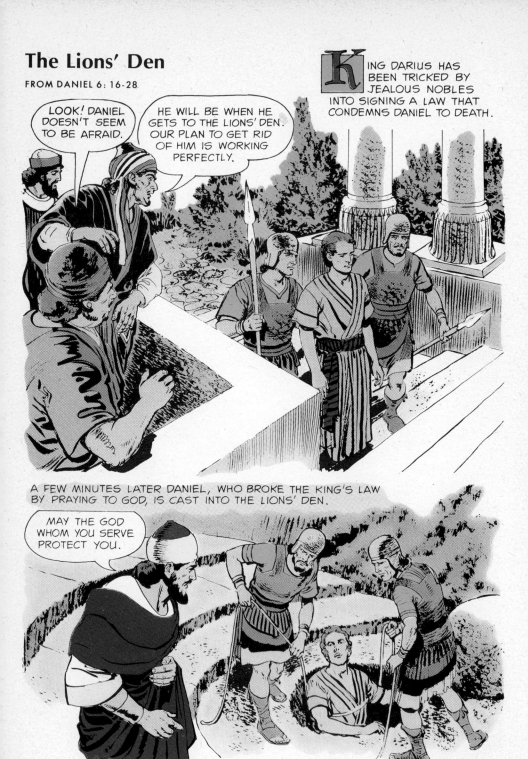

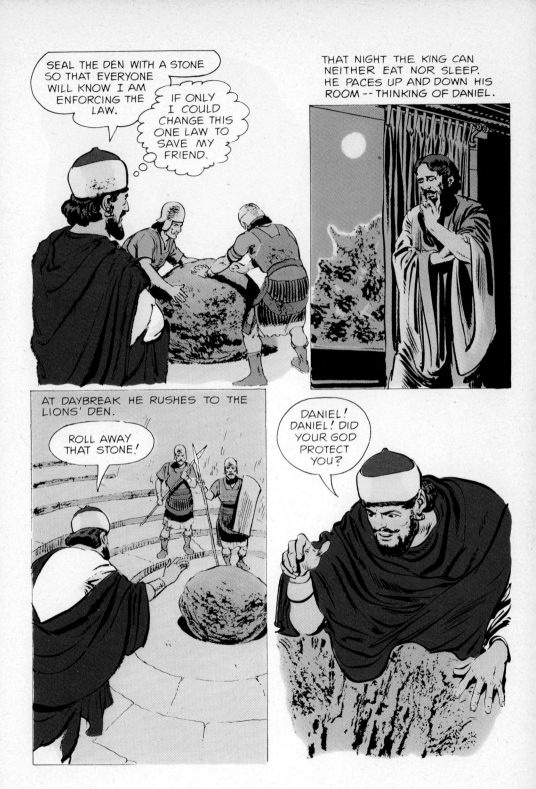

THE KING IS OVERJOYED, AND ORDERS A ROPE THROWN DOWN, AND DANIEL IS PULLED OUT OF THE DEN. THEN HE SENDS FOR THE NOBLES WHO PLOTTED DANIEL'S DEATH.

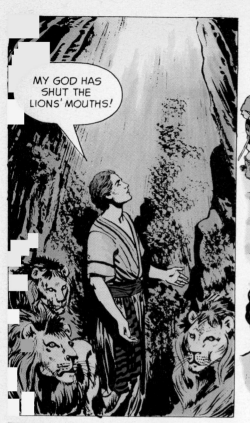

MY GOD HAS SHUT THE LIONS' MOUTHS!

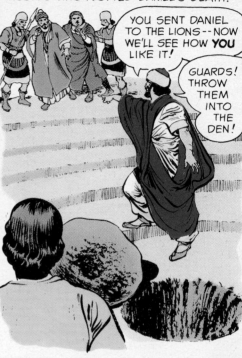

YOU SENT DANIEL TO THE LIONS -- NOW WE'LL SEE HOW **YOU** LIKE IT!

GUARDS! THROW THEM INTO THE DEN!

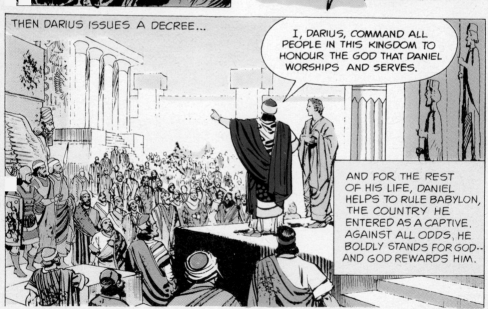

THEN DARIUS ISSUES A DECREE...

I, DARIUS, COMMAND ALL PEOPLE IN THIS KINGDOM TO HONOUR THE GOD THAT DANIEL WORSHIPS AND SERVES.

AND FOR THE REST OF HIS LIFE, DANIEL HELPS TO RULE BABYLON, THE COUNTRY HE ENTERED AS A CAPTIVE. AGAINST ALL ODDS, HE BOLDLY STANDS FOR GOD -- AND GOD REWARDS HIM.

Twelve Men of God

FROM THE MINOR PROPHETS

THE LAST TWELVE BOOKS OF THE OLD TESTAMENT ARE CALLED THE MINOR PROPHETS. EACH IS NAMED FOR A MAN WHOM GOD CALLED TO SPEAK FOR HIM AT A CRUCIAL TIME IN THE HISTORY OF ISRAEL AND JUDAH.

HOSEA -- the Prophet of Love

HOSEA LOVES HIS WIFE, GOMER, VERY MUCH. BUT ONE DAY SHE RUNS AWAY. HOSEA IS BROKENHEARTED. THEN SUDDENLY HE SEES THAT THE PEOPLE OF ISRAEL HAVE TREATED GOD THE WAY GOMER HAS TREATED HIM. GOD LOVES HIS PEOPLE, BUT THEY HAVE RUN AWAY TO WORSHIP IDOLS.

CAN GOD FORGIVE THEM? "YES," HOSEA SAYS, "FOR I CAN FORGIVE GOMER, AND GOD'S LOVE IS GREATER THAN MINE."

"GOD LOVES YOU. HE WILL FORGIVE YOUR SINS IF YOU CONFESS THEM AND WORSHIP HIM." THIS IS HOSEA'S MESSAGE TO THE PEOPLE OF ISRAEL.

AMOS -- and the Crooked Wall

JOEL -- and the Plague of Locusts

LIKE A MIGHTY ARMY DESTROYING EVERYTHING IN ITS PATH, MILLIONS OF LOCUSTS SWARM OVER THE LAND OF JUDAH. THEY DEVOUR THE CROPS -- LEAVING ONLY BARREN FIELDS BEHIND.

"WHAT WILL WE DO?" THE PEOPLE CRY.

THE PROPHET JOEL ANSWERS: "REPENT OF YOUR SINS. SEEK GOD'S HELP, AND HE WILL RESTORE THE LAND."

THEN HE ADDS THIS PROMISE: "ONE DAY GOD WILL SEND HIS HOLY SPIRIT INTO THE HEARTS OF HIS PEOPLE."

AMOS, A SHEPHERD OF JUDAH, IS WATCHING HIS SHEEP WHEN GOD CALLS HIM TO A DANGEROUS JOB. "GO," GOD SAYS, "TO THE NEIGHBOURING COUNTRY OF ISRAEL AND TELL THE PEOPLE THAT THEY ARE GOING TO BE PUNISHED FOR THEIR SINS."

WITHOUT PROTESTING, AMOS ACCEPTS THE JOB AND GOES TO THE CITY OF BETHEL IN ISRAEL.

"PREPARE TO MEET THY GOD," HE TELLS THE PEOPLE OF ISRAEL, "FOR YOU ARE LIKE A CROOKED WALL THAT MUST BE DESTROYED BEFORE A NEW ONE CAN BE BUILT."

OBADIAH --
the Angry Prophet

OBADIAH IS ANGRY AT JUDAH'S NEIGHBOUR, THE NATION OF EDOM. "YOU CHEERED," HE CRIES TO EDOM, "WHEN BABYLON DESTROYED JERUSALEM. YOU HELPED TO ROB THE CITY OF ITS TREASURES. YOU CAPTURED THE PEOPLE AS THEY TRIED TO ESCAPE AND TURNED THEM OVER TO THE ENEMY."

THEN HE PREDICTS EDOM'S PUNISHMENT: "BECAUSE YOUR CAPITAL CITY IS PROTECTED BY ROCKY CLIFFS, YOU THINK IT CANNOT BE DESTROYED. BUT IT CAN! AND IT WILL -- AS WILL EVERY NATION THAT DISOBEYS GOD."

JONAH --
the Man Who Ran Away

NINEVEH IS ONE OF THE MOST WICKED CITIES IN THE WORLD. SO, WHEN GOD TELLS JONAH TO GO TO **NINEVEH** WITH A MESSAGE TO SAVE THE CITY FROM ITS ENEMIES, JONAH RUNS THE OTHER WAY.

BUT AFTER A LESSON FROM GOD, JONAH OBEYS. HE TELLS NINEVEH TO REPENT OF ITS SINS -- AND HE PREACHES HIS MESSAGE SO SUCCESSFULLY THAT THE CITY DOES REPENT AND IS SAVED FROM DESTRUCTION.

THE MESSAGE OF THE BOOK OF JONAH IS THIS: GOD LOVES ALL PEOPLE. THOSE WHO KNOW GOD MUST TELL OTHERS ABOUT HIM.

MICAH --
Champion of the Poor

MICAH, A SMALL-TOWN PROPHET, IS A CHAMPION OF THE POOR. HE DARES TO CONDEMN THE WEALTHY LEADERS OF JUDAH AND ISRAEL.

"YOU HATE JUSTICE," HE SHOUTS, "AND YOU OPPRESS THE POOR. BECAUSE YOU DO, JUDAH AND ISRAEL HAVE BECOME SO WEAK AND CORRUPT THAT THEY WILL BE DESTROYED."

WHEN THE PEOPLE ASK WHAT GOD EXPECTS THEM TO DO, MICAH ANSWERS: "DO JUSTLY, LOVE MERCY, AND WALK HUMBLY WITH THY GOD."

AND TO THOSE WHO WILL LISTEN HE MAKES A WONDERFUL PROMISE: "IN THE LITTLE TOWN OF BETHLEHEM A SAVIOUR WILL BE BORN -- A SAVIOUR WHOSE KINGDOM OF PEACE WILL LAST FOREVER."

NAHUM
Condemns a City

WHEN THE PROPHET JONAH WARNED **NINEVEH** OF ITS WICKEDNESS, THE CITY REPENTED -- AND WAS SPARED.

NOW, ONE HUNDRED AND FIFTY YEARS LATER, ANOTHER PROPHET, NAHUM, IS CALLED TO CONDEMN **NINEVEH** FOR RETURNING TO A LIFE OF SIN.

"THE LORD IS SLOW TO ANGER," NAHUM TELLS THE CITY, "BUT HE IS NOT BLIND. HE WILL NOT LET THE WICKED GO UNPUNISHED."

THIS TIME THE CITY IS NOT SPARED -- THE ARMIES OF BABYLON SO COMPLETELY DESTROY **NINEVEH** THAT IT IS NEVER REBUILT.

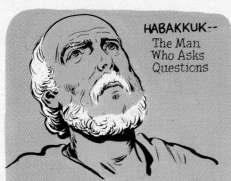

HABAKKUK-- The Man Who Asks Questions

Habakkuk is a man who asks questions-- of God.

HABAKKUK: The people of Judah are getting more wicked every day. How long will they go unpunished?

GOD: Not for long. The Babylonians are coming. I am using them to teach Judah that evil must be destroyed.

HABAKKUK: The Babylonians? Aren't they more wicked than Judah?

GOD: Yes, but have faith. In time you will understand my plans.

In the midst of all the evil around him, Habakkuk is comforted in knowing that God is in charge of the world. "God is in his holy temple," Habakkuk says, "and no matter what happens, I am not afraid, for the Lord is my strength."

ZEPHANIAH: Repent or Die

"The day of the Lord is at hand," Zephaniah warned Judah. "God will punish all nations of the earth that have disobeyed him. Neither gold nor silver will be able to deliver those who have turned from God."

Zephaniah pleads with his people to repent and seek God's forgiveness. "Those who do," he promises, "will live in peace under the rule of God."

HAGGAI-- A Temple Builder

When the Hebrews first return to Jerusalem--after years of captivity in Babylon--their first thought is to rebuild the temple. They start-- but they soon get discouraged and quit. For fifteen years nothing is done.

God speaks to Haggai and he takes the message to the people.

"Build God's temple," he preaches. And in four years it is built!

ZECHARIAH and the Triumphal Entry

Zechariah is a friend of Haggai and works with him to rebuild the temple in Jerusalem.

MALACHI-- The Final Warning

The people of Judah have returned to Jerusalem from captivity in Babylon-- the temple has been rebuilt. But still they are unhappy. And Malachi tells them why--

"You do not show respect to God. You would not dare bring cheap gifts to the governor. Yet you bring cheap and faulty offerings to God."

"God knows those who are faithful to him. He will reward them. But the unfaithful will perish as stubble in the burning fields after the harvest."

The Final Message

THE VOICE OF THE PROPHET MALACHI IS THE LAST TO
BE HEARD IN THE STORY OF THE OLD TESTAMENT. BUT
BEFORE WE HEAR HIS FINAL MESSAGE--WHICH IS
FOUND IN THE BOOK THAT BEARS HIS NAME --
LET US BRIEFLY REVIEW THE HISTORY OF THE
PEOPLE TO WHOM HE SPOKE.

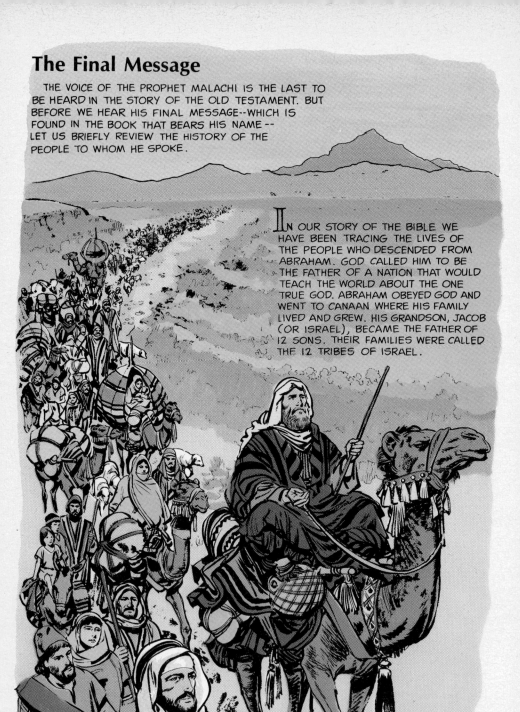

IN OUR STORY OF THE BIBLE WE
HAVE BEEN TRACING THE LIVES OF
THE PEOPLE WHO DESCENDED FROM
ABRAHAM. GOD CALLED HIM TO BE
THE FATHER OF A NATION THAT WOULD
TEACH THE WORLD ABOUT THE ONE
TRUE GOD. ABRAHAM OBEYED GOD AND
WENT TO CANAAN WHERE HIS FAMILY
LIVED AND GREW. HIS GRANDSON, JACOB
(OR ISRAEL), BECAME THE FATHER OF
12 SONS. THEIR FAMILIES WERE CALLED
THE 12 TRIBES OF ISRAEL.

WHEN A FAMINE STRUCK CANAAN THE TRIBES WENT DOWN TO EGYPT WHERE THEY LIVED FOR MANY YEARS. BUT AFTER A TIME THE EGYPTIANS TURNED AGAINST THE ISRAELITES AND FORCED THEM TO WORK AS SLAVES. THE PEOPLE CRIED TO GOD FOR HELP...

GOD HEARD THE CRIES OF HIS PEOPLE AND SENT MOSES TO LEAD THEM OUT OF EGYPT -- ACROSS THE RED SEA -- AND BACK TO THE PROMISED LAND OF CANAAN. WITH GOD'S HELP THEY CONQUERED THE LAND AND MADE IT THEIR HOME. FOR MANY YEARS JUDGES RULED OVER THE TRIBES OF ISRAEL, BUT THE PEOPLE LONGED FOR A KING.

GOD HEARD THEIR PLEA AND GAVE THEM A KING, SAUL. HE WAS FOLLOWED BY DAVID, WHO BUILT ISRAEL INTO A POWERFUL NATION. BUT IN THE YEARS THAT FOLLOWED, THE PEOPLE TURNED FROM GOD TO WORSHIP IDOLS. THEY QUARRELLED AMONG THEMSELVES, AND THE NATION WAS SPLIT INTO TWO KINGDOMS -- ISRAEL IN THE NORTH AND JUDAH IN THE SOUTH. WEAK AND CORRUPT, THEY WERE OPEN TO THE ATTACKS OF STRONGER NATIONS AROUND THEM.

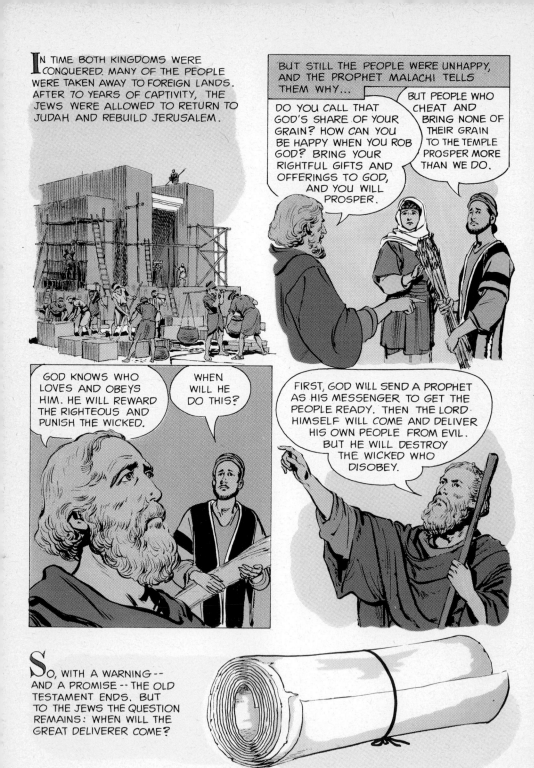

IN TIME BOTH KINGDOMS WERE CONQUERED. MANY OF THE PEOPLE WERE TAKEN AWAY TO FOREIGN LANDS. AFTER 70 YEARS OF CAPTIVITY, THE JEWS WERE ALLOWED TO RETURN TO JUDAH AND REBUILD JERUSALEM.

BUT STILL THE PEOPLE WERE UNHAPPY, AND THE PROPHET MALACHI TELLS THEM WHY...

DO YOU CALL THAT GOD'S SHARE OF YOUR GRAIN? HOW CAN YOU BE HAPPY WHEN YOU ROB GOD? BRING YOUR RIGHTFUL GIFTS AND OFFERINGS TO GOD, AND YOU WILL PROSPER.

BUT PEOPLE WHO CHEAT AND BRING NONE OF THEIR GRAIN TO THE TEMPLE PROSPER MORE THAN WE DO.

GOD KNOWS WHO LOVES AND OBEYS HIM. HE WILL REWARD THE RIGHTEOUS AND PUNISH THE WICKED.

WHEN WILL HE DO THIS?

FIRST, GOD WILL SEND A PROPHET AS HIS MESSENGER TO GET THE PEOPLE READY. THEN THE LORD HIMSELF WILL COME AND DELIVER HIS OWN PEOPLE FROM EVIL. BUT HE WILL DESTROY THE WICKED WHO DISOBEY.

SO, WITH A WARNING -- AND A PROMISE -- THE OLD TESTAMENT ENDS. BUT TO THE JEWS THE QUESTION REMAINS: WHEN WILL THE GREAT DELIVERER COME?